**In Celebration of the**
THE JOHN AND MABLE RINGLING MUSEUM OF ART
**50th Anniversary**
**1930-1980**

Copyright © 1981
The John and Mable Ringling Museum of Art Foundation
LCC 81-80371
ISBN 0-916758-04-4
Design and layout/Tony Falcone and Jim Waters
Printing/Florida Graphic Arts, Sarasota.
Typesetting/Gan Eden, Sarasota.

MASTERWORKS
*from*
THE JOHN AND MABLE RINGLING MUSEUM OF ART
The State Art Museum of Florida

**Loan Exhibition**
**Summary catalogue and introduction**
**by**
**Denys Sutton**

**Wildenstein Galleries**
19 East 64th Street, New York
**April 1 - May 8, 1981**

**The Tampa Museum**
600 Doyle Carlton Drive
Tampa, Florida
**June 14 - September 6, 1981**

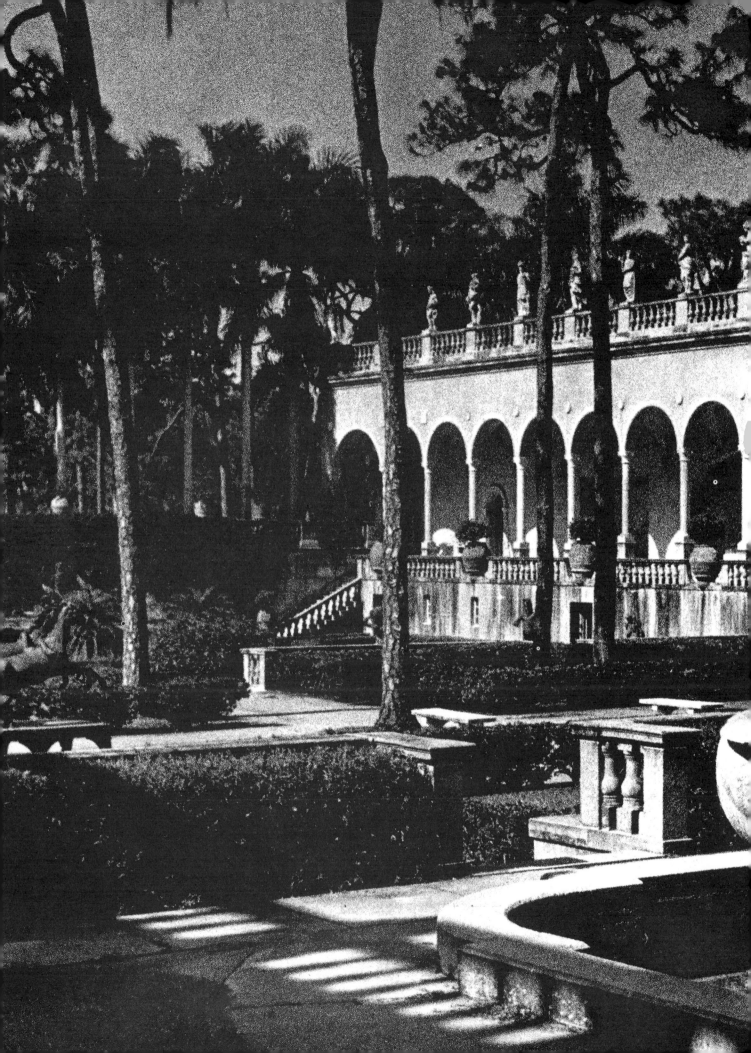

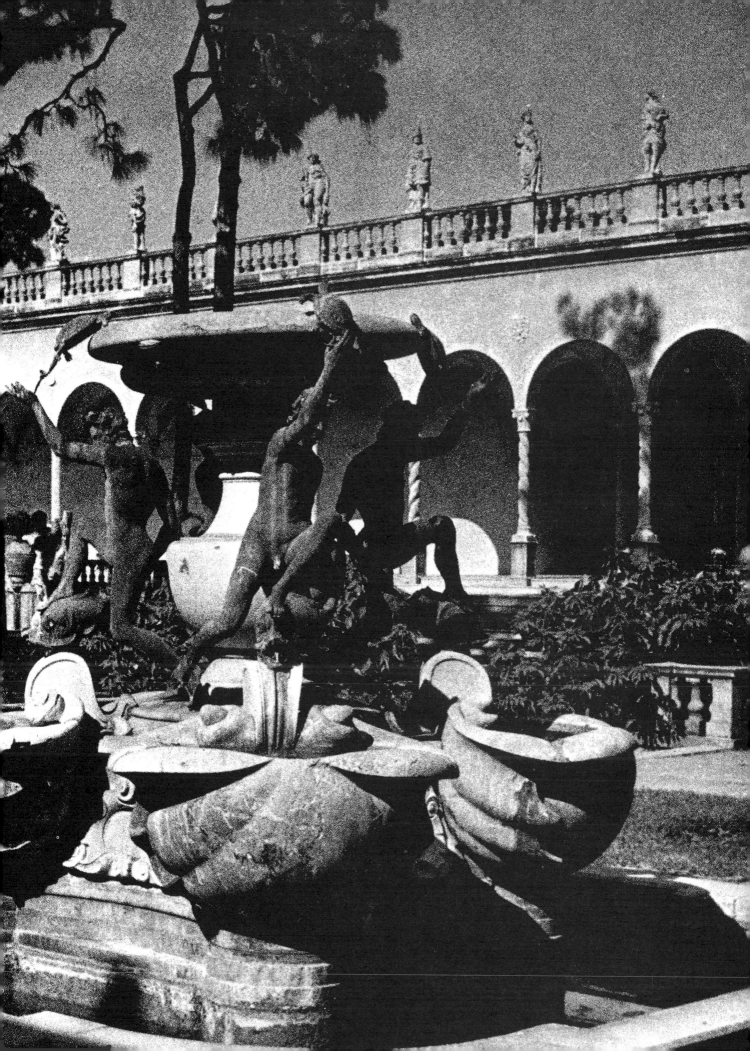

# A Voyage of Discovery

*Denys Sutton*

Those who enjoy entertainment immediately respond to the name Ringling for it conjures up a world of sawdust and grease paint, clowns and trapeze artistes, lions and elephants and the colourful and often dramatic life of the circus. Enthusiasts for the Baroque know that the name is also that of a museum on the west coast of Florida which for long was an outpost of this style in the United States.

Many know about the Ringling Museum at Sarasota only from the small catalogue produced by William Suida in 1949 and more recently from the detailed ones of the Italian, Dutch and Flemish schools. These constitute an invitation to a voyage of discovery and those who go to the Ringling Museum undergo an exceptional experience.

The building is delightful with its pink-coloured facade, its inner court with flowers, steps, terraces, fountains and statues; the galleries are spacious. There is nothing newfangled or institutional about this museum, rather it is reminiscent of some palace or villa in southern Italy. This effect is heightened by the view of the serene blue water of the Gulf of Mexico and by the *Bigonia grandiflora,* the lizards which would have delighted D.H. Lawrence, and the sound of crickets. This is a place for lovers of life as well as of art — an oasis in an increasingly mechanized world.

To walk down to the water's edge and stand on the balcony outside the Ca'd'Zan, the name of the house built by John and Mable Ringling, is to enter a dream world: here the pelicans can be seen swooping down to seize fishes.

The villa, the history of which has been recounted by James Maher in an engaging volume, *The Twilight of Splendor* (1975), is Mrs. Ringling's tribute to Venice. The house has charm and style and it contains furniture from the famous Villa Palagonia in Sicily, Alfred Steven's entertaining painting of Parisian celebrities who include Sarah Bernhardt, Bizet, Massenet and Sardou, and mementoes of John Ringling — his hats, striped trousers and elegant footwear, of a style that used to be known in England as 'correspondent's shoes'.

In this theatrical setting, the genial circus master entertained his guests, among whom were 'Jimmy' Walker, Mayor of New York, Florenz Zeigfeld and Baron Detlev von Hadeln, then a leading expert on sixteenth-century Venetian painting. Smiling, carefully barbered, a late riser, Ringling was very much the impresario; understandably the floating, fluent movements and the grand gestures of the Baroque appealed to him.

Of German extraction, Ringling made annual tours to Europe to find new turns for his circus. In 1922-23 he met in New York one of the major art dealers of the day, Julius Böhler of Münich. The two men got on well: Ringling pressed Böhler into service to find architectural elements for the luxury hotel he was then building in Sarasota. When they were together in Naples in 1925, Ringling consulted Böhler about his idea to erect a museum, naturally a scheme favoured by the latter. Ringling started by buying a noble Veronese, *The Rest on the Flight into Egypt,* and Luini's *The Madonna and Child with SS. Sebastian and Roche.* The former was once in the Electoral Gallery at Dusseldorf, the latter in the Ducal Palace in Weimar.

Various successful enterprises, including speculation in oil, permitted Ringling to collect lavishly. During the next five years he bought on the scale of the Milords of Grand Tour days and he shared their tastes. One of Ringling's major coups came when he heard that Rubens' four large cartoons for *The Triumph of the Eucharist* had gone unsold at the Duke of Westminster's sale at Christie's in 1924 and were to be seen in the old ballroom at Grosvenor House, London, which was then still standing. With typical flair Ringling realised that their acquisition would make him the only owner of large-scale works by this master in the United States. These four huge works have travelled much since their creation, going from the palace of the Infanta Isabella Clara Eugenia at Brussels to the Church of the Discalced Carmelite Nuns at Loeches. In about 1808 they were moved from there by George Wallis who was acting on behalf of William Buchanan, the Duveen of his day, and then they were acquired by Bourke, the Danish plenipotentiary at Madrid who disposed of them to the first Marquess of Westminster. The aged Bode, the former head of the Kaiser Friedrich Museum, Berlin, in a letter to Böhler, commended Ringling's appreciation of Rubens and general willingness to acquire large pictures.

Doubtless pictures with noble provenances appealed to Ringling, as they have done before and since to collectors. Acting on his behalf, Böhler tracked down other pictures from the Grosvenor sale. Ringling bought many works at auction and was especially active at the sale in 1928 of the collection formed by Robert Holford, a great Victorian virtuoso. On this occasion he acquired one of his most appealing Italian Renaissance pictures, Gaudenzio Ferrari's *The Holy Family with a Donor,* and the intriguing picture of Philip IV which once belonged to the King of Holland and which some pundits consider to be all, or in part, by Velázquez.

When pictures from the collection of the Earl of Yarborough came under the hammer in 1929, Ringling purchased the noble late Poussin, *Holy Family* and Guercino's *The Annunciation,* which Sir Richard Worsley had obtained from the Church of Santa Croce, Confraternitá della Morte, Reggio Emilia.

John Ringling also bought pictures from dealers such as A.L. Nicholson, who had a gallery in New York, Robert Langton Douglas, Agnews and Duveens. These acquisitions included Gainsborough's immense and impressive equestrian portrait of General Philip Honeywood. In 1928-29, he purchased from Duveens *en bloc* the collection of Mrs. Oliver Belmont which included a *Madonna and Child* from the School of Roger Campin, a crisp *St. Jerome* by Jacopo Sellaio and the famous Piero di Cosimo, *The Building of a Palace,* which expresses the complex imagery of the Florentine Renaissance. As Mrs. Belmont's ex-husband was William K. Vanderbilt, these pictures presumably hung in his famous New York residence, a Loire Valley chateau by R.M. Hunt at 640 Fifth Avenue and would have been seen by the 'beau monde' and leading artists of the day.

That many pictures from the same collection are now in the Ringling Museum gives the museum a companionable air; here the historian of taste comes across works for which he may have been looking over the years, such as Rubens' *The Departure of Lot and His Family from Sodom* which was presented by the City of Antwerp to the great Duke of Marlborough after his victories over the French.

Ringling was a man of eclectic tastes, so that it is hardly surprising to find so many unusual pictures in his collection, such as Martin van Meyten's bold portraits of the Empress Maria Theresia and the Emperor Francis I. As befitted a man who spent much of his life in staging shows, Ringling was a good judge of painting; so for that matter were two other impresarios of his generation, Charles Cochran and Serge Diagheliev. Ringling was a clever and courageous buyer and did not mind paying a high price for a picture that caught his fancy, such as Frans Hals' *Portrait of Pieter Jacobsz. Olycan.* He gave £20,000 for this in 1927, but he could have made a handsome profit on his purchase for Duveen offered him three times this price.

The last years of Ringling's life were not without their troubles. Fortune turned against him. He had great difficulty in keeping afloat during the Depression but with the aid of his relations he survived and the collection remained intact. On his death he had only a few hundred dollars in the bank.

When he died, Ringling left his entire estate, including the art museum, collections and house, to the State of Florida. From his death in 1936, until 1946, the estate was in litigation. When the legal problems were settled, the museum hired Everett A. Austin as the first director and opened to the public in 1948 (the museum had been sporadically open from 1930 to Ringling's death in 1936, but without a professional staff). 'Chick' Austin, whose career is sketched in my Editorial in *Apollo,* December, 1966, is an almost legendary figure in collecting circles for he had bought with immense flair for the Wadsworth Atheneum, Hartford. This friend of Virgil Thompson and

the Sitwells, was a connoisseur with a love for the unusual work of art. His regime at the Ringling Museum meant that the collection was enriched with items that would have pleased the founder, such as the eighteenth-century theatre from Asolo and the group of pictures of the adventures of Harlequin by the Florentine painter, Giovanni Domenico Ferretti, which came from Schloss Leopoldskron, Salzburg, the home of Max Reinhardt, one of the leading theatrical producers in Central Europe from the 1910s to the early 1930s.

It was Austin who arranged the delightful museum devoted to the circus which lies a minute or two away from the main building. It contains many rare and unusual prints and posters of circus life and extremely decorative examples as the 'Cage Wagon' of the early 1900s, the 'Lion and Gladiator Bandwagon' (c. 1910) and the 'Two Jester's Calliope Wagon' of 1920. This museum would have delighted Degas, Edmond de Goncourt, Sickert and Toulouse Lautrec.

During Austin's directorship, Osbert Sitwell visited Sarasota, and fell in love with the place and the museum. At that time, the town was still the winter quarters of the Circus and Sitwell, connoisseur of nostalgia, recalled in *The Four Continents* (1954) the white-painted railway train that took the Circus on tour, the performances that were given on Saturday nights at the John Ringling Hotel and a troupe of fifty elephants, all female, as the presence of male ones caused trouble. He had a great affection for elephants and in his essay he supplies one gobbet of information that may be as unfamiliar to the student of modern music as it is to the lover of elephants, namely that the animals have special tastes in music. They appreciate Delibes, Massenet and Gounod, but draw the line at the avant-garde, so when John Ringling North commissioned Stravinsky to compose a march for them, the elephants showed their disapproval at the result by refusing to budge: they staged a sit-down strike!

The elephants have left Sarasota but a sense of fun still radiates the Ringling Museum. That the Baroque and the Rococo are honoured there is as it should be; they were styles of illusionism and fantasy; they contribute embellishment of life, and so does John Ringling's vision of art.

## Catalogue

This catalogue makes no claim to being the result of original work. The entries on the Italian pictures are based on the catalogue of this School by Peter Tomory (1976) and those on the Flemish and Dutch Schools on that by Franklin W. Robinson and William H. Wilson with contributions by Larry Silver (1980). The entries on those works which belong to other schools are derived from William Suida's pioneering catalogue of 1949 and in the case of those items acquired since then on material in the Museum archives. In the case of the pictures dating from Suida's time I have supplied a reference to his catalogue. 'SN' with a number refers to the Museum Registration Number. Paintings are listed in alphabetical order but are illustrated in a rough chronological sequence. My thanks are due to Richard S. and Mary-Lou Carroll, Mrs. Elizabeth Telford and William H. Wilson for their collaboration in staging a show which, we all hope, would have pleased John and Mable Ringling.

**D.S.**

## Willem van Aelst
Dutch, 1626-1683

i. *Still Life with Dead Game* (SN 655)

> Oil on canvas,
> 53⅞ x 41⅞ in. (136.8 x 106.4 cm.)
> Signed between centre and lower left: *Guillaume van Aelst*

**Coll:** D.A. Hoogendijk, Amsterdam;
acquired, 1951

**Lit:** Robinson and Wilson, 1980, no. 58

**Plate 33**

During the 1650s and 1660s, van Aelst began to paint large scale still life compositions. This painting may be related stylistically to one of 1668 in the Kunsthalle, Karlsruhe. The tones of the picture and the pose of the dead hare suggest that it is the sort of work that may have exerted some influence on Chardin.

## Anonymous
French, c. 1600

2. *Scene from the Commedia dell'Arte* (SN 688)

> Oil on canvas,
> 46⁹⁄₁₆ x 58⅛ in. (118.3 x 147.6 cm.)

**Coll:** John Conyers, c. 1765;
Conyers, Copped Hall, Essex, until 1869;
F.J. Wythes until 1946;
Sabin, London, 1946-54;
acquired from Durlacher Brothers, N.Y., 1955

**Plate 27**

The attribution of this lively painting, which dates from c. 1600, has given rise to much discussion. Over the years it has been ascribed to the School of Fontainebleau, the Genoese School, to a painter from Lyons, to the Nancy painter, Jacques Bellange, and to a Flemish artist working in France. M. Laclotte and Sylvie Béguin point out in *Fontainebleau: Art in France, 1528-1610,* National Gallery of Canada, Ottawa, 1973 (29) that the man in the centre might be Zani and that the large hats of the women are typical of gipsies (*bern,* wheels wrapped in headbands). The gipsy on the right may be compared to a figure in a drawing *The Finding of Moses* (Louvre, RF 569) by Niccolò dell'Abbate, which was reproduced in a tapestry (illustrated in Sylvie Béguin, *L'Ecole de Fontainebleau,* 1960, p. 121).

## Francesco del Cairo
Italian, 1607-1664

3. *Judith with the Head of Holofernes* (SN 798)

> Oil on canvas,
> 46⅞ x 37⅛ in. (119 x 94.3 cm.)

**Coll:** Gunnar A. Sadolin, Copenhagen, c. 1963;
with Gallery Lasson, London, 1966;
acquired 1966.

**Lit:** Tomory, 1976, no. 40.

**Plate 14**

The attribution of this work to the Milanese master Francesco del Cairo is not entirely certain; it was presumably painted c. 1630-35, during the first Milanese period. A variant is in the Larguier Collection, Uzés, France.

## After **Robert Campin**
### Flemish, c. 1375-1444

**4.** *Virgin and Child in an Apse* (SN 196)
> Oil and tempera on panel,
> 18⅛ x 13⅞ in. (45.7 x 34.9 cm.)

**Coll:** Emile Gavet, Paris;
> William K. Vanderbilt;
> Mrs. Oliver Belmont, Newport, R.I.;
> with Duveen, 1928-29;
> acquired Ringling Bequest, 1936.

**Lit:** Robinson and Wilson, 1980, no. 9.
> **Plate 1**

This seems to be the best version of a lost original by the Tournai master Robert Campin, of which other examples exist, including one in the Metropolitan Museum, New York.

The Virgin in the Ringling Museum painting resembles the Virgin in the *Nativity* in the Dijon Museum. "The presentation of the Madonna with angels in an apse," writes Larry Silver in the Ringling catalogue, "is based upon a traditional medieval metaphor of the Church as the image of heaven."

## **Alonso Cano**
### Spanish, 1601-1667

**5.** *St. John the Evangelist's Vision of God* (SN 344)
> Oil on canvas,
> 28 x 15½ in. (71.1 x 40 cm.)

**Coll:** Convent of Santa Paula, Seville;
> taken by Marshal Soult, Duc de Dalmatie in 1810;
> his sale, Paris, May 1852, lot 45; Duc de Galleria, no. 344;
> acquired Ringling Bequest, 1936.

**Lit:** Suida, 1949, no. 344.
> **Plate 24**

This painting and no. 6 were originally placed on each side of the statue of St. John the Evangelist, in the altar of St. John in the Church of Santa Paula in Seville. This altarpiece is reconstructed by Jeannine Baticle in her article, "Deux tableaux d'Alonso Cano. Essai de reconstitution d'un retable," *La Revue du Louvre*, 2, 1979, pp. 123ff.

Harold E. Wethey points out in *Alonso Cano* (1955, p. 169) that before leaving for Madrid in January, 1638, Cano arranged for his friend, Juan del Castillo (1584-1640) to complete the pictures as well as the gilding and the painted ornamentation. This author considers these two paintings to be by Castillo after Cano.

**6.** *St. John the Evangelist's Vision of the Lamb* (SN 345)
> Oil on canvas,
> 28 x 15½ in. (71.1 x 40 cm.)
> **Plate 25**

A pendant to no. 5.

## Giovanni Antonio Canaletto
Italian, 1697-1768

**7.** *Piazza San Marco, from Campo San Basso* (SN 186)

        Oil on canvas,

        16⅛ x 12¼ in. (40.9 x 31.1 cm.)

  **Coll:**   A.J. Pilkington, Co. Antrim, sale, Christie's, July 25, 1930, lot 30;

        acquired Ringling Bequest, 1936.

    **Lit:**   Tomory, 1976, no. 81.

        **Plate 39**

This small painting, no. 8 in the exhibition and no. 339 in W.G. Constable and J.G. Links *Canaletto* (1977) seems to be the only paintings by Canaletto showing the Torre dell'Orologio in the form it took after 1755 when Massari added a new, set-back, top-storey and remodeled the ground floor and mezzanine facades. By this time, Canaletto had finally returned to Venice from England. A drawing, with differences from this work, is in the Musée Conde, Chantilly and a replica drawing, with differences, is in the Royal Institute of British Architects, London. There is also a related etching, De Vesme, no. 22.

**8.** *The Riva Degli Schiavoni Towards the East* (SN 187)

        Oil on canvas,

        14½ x 11 in. (37 x 28 cm.)

        **Plate 39**

A pendant to no. 7.

## Luca Carlevaris
Italian, 1665-1731 and
## Giovanni Richter

**9.** *Piazza San Marco Towards San Marco* (SN 669)

        Oil on canvas,

        25 x 39½ in. (75 x 117 cm.)

  **Coll:**   Duke of Newcastle, Clumber Park;

        by inheritance the Earl of Lincoln;

        with D.A. Hoogendijk, Amsterdam, 1938-39 (?);

        Baron van der Goes van Dirxland;

        with Hoogendijk; acquired 1953.

    **Lit:**   Tomory, 1976, no. 83

        **Plate 37**

In his book on Carlevaris (1967), A. Rizzi points out the existence in this picture and its pendant of the hand of a collaborator similar to that found in two pictures in the Italico Brass Collection. This hand seems to be that of Giovanni Richter; it seem probable that whilst the former painted the landscape, the latter executed the figures.

## Luca Carlevaris
Italian, 1665-1731 and
## Giovanni Richter
10. *Piazza San Marco Towards the Piazetta* (SN 670)
   Oil on canvas,
   25 x 39¾ in. (75 x 117 cm.)
   **Plate 38**

A pendant to no. 9.

## Agostino Carracci
Italian, 1557-1602
11.
*Susanna and the Elders* (SN 111)
   Oil on canvas,
   63¹⁵⁄₁₆ x 43⅞ in. (162.3 x 111.4 cm.)
   **Coll:** Villa Aldobrandini (since it was painted);
   William Y. Ottley (purchased from the Aldobrandini family as Annibale) 1798-99;
   sale, Christie's, May 16, 1801, lot 30;
   J. Humble sale, Christie's, July 15, 1927, lot 40 (as Ludovico);
   acquired Ringling Bequest, 1936.
   **Lit:** Tomory, 1976, no. 129.
   **Plate 10**

This painting, representing feminine virtue, was commissioned as a betrothal picture for Ranuccio Farnese and Margherita Aldobrandini who were married in 1600. It would have been painted at that time, or slightly earlier and is mentioned in the Aldobrandini inventory of 1682. In addition to the details provided by Tomory, it may be stated that the picture was shown in the anonymous exhibition of Ottley's paintings, held at 118 Pall Mall, London, January, 1801. A variant by a follower of the artist is at Christ Church, Oxford (no. 203).

## Pietro da Cortona
Italian, 1596-1669
12. *Hagar and the Angel* (SN 132)
   Oil on canvas,
   45 x 58¹³⁄₁₆ in. (114.3 x 149.4 cm.)
   Engraved by J. Fittler for Bowyer's *Bible,* 1795.
   **Coll:** Earl Waldegrave sale, Prestage, London, November 16,
   1763, lot 45, bought by Brown;
   First Earl Grosvenor;
   by inheritance Duke of Westminster;
   sale, Christie's, July 4, 1924, lot 9;
   with Hibbard;
   sale, Southby, June 30, 1926, lot 44;
   anon. sale, Christie's, May 9, 1930, lot 143;
   with Vitale Bloch;
   acquired Ringling Bequest, 1936.
   **Lit:** Tomory, 1976, no. 135
   **Plate 16**

The exquisite colours of this charming painting help to explain Pietro da Cortona's popularity in the eighteenth century and the influence that his work exerted in France. Giuliano Briganti, in his book on the painter (1962), dated it to c. 1638, relating it to a larger picture, *Hagar Returning to Abraham,* in the Kunsthistorisches Museum, Vienna, no. 170, of c. 1637.

A copy is in the Landesmuseum, Hannover.

## Piero di Cosimo
### Italian, c. 1462-1521

**13.** *The Building of a Palace* (SN 22)

    Oil on panel,
    32½ x 77½ in. (82.6 x 196.9 cm.)

**Coll:** Mussin Pouschkine, 1836;
Meazza, Milan;
sale, Sambon, April 15ff., 1884, lot 61 (as Signorelli);
Emile Gavet, Paris;
William K. Vanderbilt;
Mrs. Oliver Belmont, Newport, R.I.;
purchased by Ringling through Duveen, 1928-29;
acquired Ringling bequest, 1936.

**Lit:** Tomory, 1976, no. 8.

**Plate 4**

Although Berenson attributed this intriguing picture to Piero di Cosimo in his 1932 lists, he changed his mind in those issued in 1936 and gave it to Giuliano Bugiardini. However, since the publication of Langton Douglas's monograph (1946) and Suida's catalogue it has been ascribed to Piero, the only bones of contention being its date and the identification of the subject. Zeri and Fahy have dated it to c. 1507; Douglas and Bacci considered it later, c. 1520.

The view that the picture might be fitted in with a cycle, *The Early History of Man*, has now been abandoned in the light of the findings of Webster Smith and James A. Ackerman that the architectural style of the palace is that of Giuliano di San Gallo: Ackerman noted that the prototype was this architect's double unit villa at Poggio a Caiano, and, writes Tomory: "since statues in the parapet were not introduced until c. 1515 at Verona" the palace in this picture could not be earlier than c. 1520.

Tomory proposes that this painting is an allegory — *The Triumph of Architecture* — and an *in memoriam* valediction of the San Gallo family and its life-long association with the House of Medici. This unusual work, with its artistic and literary associations suggests that for Piero the memory was at work and that the picture is "a fading vision of a Golden Age."

## Lucas Cranach the Elder
### German, 1472-1553

**14.** *Cardinal Albrecht of Brandenburg as St. Jerome* (SN 308)

    Oil on panel,
    45¼ x 35⅟₁₆ in. (114.9 x 89 cm.)
    dated, with monogram (?), on leg of table, lower left, 15?6.

**Coll:** Ducal collection of Sahlzdahlen (inv. of 1744, no. 349,
and 1789-1803, no. 237) sold 1811;
Rat Hollandt, Brunswick, Germany, 1851;
Oberst van Natzmer, Potsdam, 1900;
Schröder, Melzen, 1925;
P. Cassirer, Berlin, 1926;
John Ringling, 1932;
acquired Ringling Bequest, 1936.

**Plate 2**

Cardinal Albrecht of Brandenburg was painted by Cranach on several occasions; see Max. J. Friedländer and Jacob Rosenberg, *The Paintings of Lucas Cranach*, 1978, nos. 182-185. Cranach began working for the cardinal in 1520, in which year he executed his portrait engraving (F. Lippman, *Lucas Cranach*, 1895, no. 64) of this powerful ecclesiatic who was Elector of Mainz. This print, in fact, is no more than a free copy of Dürer's portrait engraving of the Cardinal of 1519. Friedländer and Rosenberg suggest that it seems probable that Cranach never drew the Cardinal from life, but based all his subsequent portraits on this prototype. For the relationship between Cardinal Albrecht and Cranach see Friedländer and Rosenberg, op. cit., no. 182.

Another painting of the Cardinal, which is close to the Ringling example, is in the Hessisches Landesmuseum, Darmstadt (see Friedländer and Rosenberg, no. 185).

### Francesco Desiderio (Francois Didier Nomé)
French, worked in Italy, 1593 - still active, 1628

**15.** *Martyrdom of St. Januarius* (SN 633)

> Oil on canvas,
> 16¾ x 38 in. (42.5 x 96.5 cm.)

**Coll:** Moratilla, Paris (as Magnasco until 1924);
with D. Koester, New York;
acquired, 1950.

**Lit:** Tomory, 1976, no. 153.

**Plate 11**

St. Januarius, an early Christian martyr, is particularly identified with the liquefaction of his blood. The martyrdom of St. Januarius may have had some theatrical enactment in Desiderio's time, as Tomory observes in an informative note.

### Jacob van Es
Flemish, c. 1596-1666

**16.** *Still Life with Oysters* (SN 661)

> Oil on panel,
> 21¼ x 29 in. (54 x 73.7 cm.)
> Signed lower left on edge of table: *JACO. VS* and
> monogrammed toward hilt area of knife blade: *VS*

**Coll:** Count Edmund von Kesselstatt, Trier, 1844, inv. no. 27;
sale, Gallery Fischer, Lucerne, 7-10 May, 1947, no. 1037;
with Newhouse Galleries, New York;
Frederick Mont, New York,;
acquired, 1952.

**Lit:** Robinson and Wilson, 1980, no. 16.

**Plate 21**

This still life, which may be related to other works by the master in the Ashmolean Museum, Oxford and the Musée des Beaux-Arts, Brussels, possibly possesses an allegorical meaning: for instance, the juxtaposition of the orange of original sin and the oysters of lust, opposed to the bread and wine of the Eucharist. The chestnuts in the Delft or Chinese bowl may represent the wood of the cross *(lignum crusis),* for the life which is revealed to us.

### Gaudenzio Ferrari
Italian, c. 1480-1546

**17.** *The Holy Family with a Donor* (SN 41)

> Panel,
> 60½ x 45½ in. (153.6 x 115.6 cm.)

**Coll:** Conte Taverna, Milan, until after 1610;
with Farrer, London;
Robert Holford by 1845;
Sir George Holford sale, Christie's, July 15, 1927, lot 49;
acquired Ringling Bequest, 1936.

**Lit:** Tomory, 1976, no. 43.

**Plate 6**

The dating of this beautiful painting poses a problem; was it executed at the start or at the end of the 1520s? Tomory argues that the naturalism shown in the picture (which for him retains traces of Mantegna's influence and reflects Leonardesque idealism) presents an interpretation of the High Renaissance style; this would necessarily place it in the early 1520s before Ferrari's mannerist phase of c. 1525.

A preparatory drawing, possibly for the head of the Madonna, is known (formerly Slatkin Galleries, New York, 1962). An untraced variant was formerly in the French Royal Collection; two copies are also known.

## Giovanni Domenico Ferretti
### Italian, 1692-1766/68

**18.** *Harlequin as Crippled Soldier* (SN 637)
    Oil on canvas,
    38⅜ x 30¾ in. (97.4 x 78.1 cm.)
    Engraved by Bartolozzi.
  **Coll:** Max Reinhardt, Schloss Leopoldskron, Salzburg;
    acquired, 1950.
    **Lit:** Tomory, 1976, no. 11.
    **Plate 41**

This group of enchanting paintings of the Commedia dell'Arte appropriately once belonged to Max Reinhardt, the famous theatrical producer and director. In his book on Feretti (1968), Edward A. Maser thought that the Accademia del Vangelista may have commissioned the artist to paint them as a result of the visit to Florence in 1742 of the celebrated Venetian playwright, Carlo Goldoni. While in the city, Goldoni wrote two plays for the Accademia: *Aventura di Arlecchino e Camilla* and *Le Trenta Due Disgrazie diArlecchino.*

Gerhard Ewald points out in the catalogue of the exhibition *The Twilight of the Medici,* held at Florence and Detroit in 1974 (p. 228), that Feretti was a friend of the Florentine poet Giovanni Battista Fagiuolo (1660-1742) who enlarged the repertory of the Commedia by introducing contemporary figures into his comedies. Designs after Feretti's compositions were also made for Doccia porcelain that were never used.

**19.** *Harlequin as Peasant* (SN 638)
    Oil on canvas,
    38¼ x 30½ in. (97.1 x 77.5 cm.)
    **Plate 42**

In series with no. 18.

**20.** *Harlequin as Scholar* (SN 639)
    Oil on canvas,
    38½ x 31 in. (97.7 x 78.7 cm.)
    **Plate 43**

In series with no. 18. A variant is in the Bottari Collection, Rome.

**21.** *Harlequin as Beggar* (SN 641)
    Oil on canvas,
    37 3/4 x 30 1/2 in. (95.8 x 77.5 cm.)
    **Plate 44**

In series with no. 18.

**22.** *Harlequin as Doctor* (SN 644)
    Oil on canvas,
    38½ x 30¾ in. (97.7 x 78.1 cm.)
    **Plate 45**

In series with no. 18.

**23.** *Harlequin as Brigand* (SN 645)
    Oil on canvas,
    38¼ x 30¾ in. (97.1 x 78.1 cm.)
    **Plate 46**

In series with no. 18. A drawing connected with this painting is in the Ashmolean Museum, Oxford (no. 991).

**24.** *Harlequin as Rejected Lover* (SN 646)
    Oil on canvas,
    38⅜ x 30½ in. (97.4 x 77.5 cm.)
    **Plate 47**

In series with no. 18.

### Giovanni Domenico Ferretti
Italian, 1692-1766/68

**25.** *Harlequin as Dancing Master* (SN 649)
Oil on canvas,
38½ x 30½ in. (97.7 x 77.5 cm.)
**Plate 48**

In series with no. 18.

**26.** *Harlequin as Lacemaker* (SN 650)
Oil on canvas,
38½ x 30½ in. (97.7 x 77.5 cm.)
**Plate 49**

In series with no. 18.

**27.** *Pulcinella with a Cooking Pot* (SN 651)
Oil on canvas,
37¾ x 30½ in. (95.8 x 77.5 cm.)
**Plate 50**

In series with no. 18.

### Luca Forte
Italian, active 1640-1670

**28.** *Still Life with Fruit* (SN 715)
Oil on canvas,
31⁷⁄₁₆ x 41½ in. (78.9 x 104.7 cm.)
Signed and inscribed: *L.F.* left centre bottom;
*Don Joseph Carrafas* below the bird.
**Coll:** Mortimer Brandt; acquired, 1961.
**Lit:** Tomory, 1976, no. 154.
**Plate 17**

De Dominici in *Vite de' pittori . . . napoletani* (1742), implies that Forte was the founder of the Neopolitan School of still life painters but little seems to be known about him. There is no precise explanation of the meaning of the words *Don Joseph Carrafas* inscribed on the picture. He might be identifiable with the brother of the Duke of Maddalone who was a participant in the revolt led by Masaniello in Naples in 1647, during which he was lynched.

### Fede Galizia
Italian, c. 1578-1630

**29.** *Judith with the Head of Holofernes* (SN 684)
Oil on canvas,
47½ x 37 in. (120.5 x 94 cm.)
Signed and dated *Fede Galizia 1596* on the sword blade.
**Coll:** Palazzo Reale, Turin (?);
Hinman, Maine;
Logan Smith, Sarasota;
acquired, gift of Jacob Polak, 1969.
**Lit:** Tomory, 1976, no. 46.
**Plate 9**

A variant, signed and dated 1601, is in the Galleria Borghese, Rome, another version, possibly identical with the Ringling picture, was in the Palazzo Reale, Turin.

## Pierre Gaudreau
### French, 1694-1731

**30.** *The Lover's Pilgrimage* (SN 671)
    Oil on canvas,
    32³/₁₆ x 25⅝ in. (81.8 x 65.1 cm.)
**Coll:**  Court Sculptor Egel, Mannheim;
    August Goldschmidt, München;
    acquired from Adolph Loewi, 1952.
    **Plate 31**

This is a rare work by a French-born artist who spent most of his life in the service of Kurfurst Karl III, Philip von der Pfalz at Mannheim. Various signed and dated works by this painter are listed in Thieme-Becker's *Kunstlerlexicon* but since the relevant volume was published in 1921, their present whereabouts may now be different.

A.L. Mayer, who published this painting for the first time in *Pantheon* (January 9, 1932, p. 32, repr.) when it was in the Goldschmidt Collection, notes that it may be identified with a picture mentioned by Chréstien Louis Hagedorn in *Lettre à un amateur de la Peinture avec des Eclaircissements Historiques sur un Cabinet . . .* 1775, p. 253:

> "J'aurois a me reprocher, si j'oubliois ici un Peintre Francais, nommé Gotreau, mort assez jeune, je crois à Manheim, ou il a laissé des preuves de ses talents pour l'histoire, dans un Tableau qui décore l'Autel de la Chapelle du Chateau. Il a demeure à Manheim du tems de feu l'Electeur Charles Philippe. On voit de sa main dans un meme ville chez le Sr. Egel, fameus sculpteur, un espece de Régard, en Berger et Bergère, peint avec gout."

The tender attitude shown by the "pilgrims" toward each other suggest that they are voyagers to Cythera, the mythical island sacred to Venus, rather than pilgrims to Compostella which the cockle shell and staff normally would indicate.

## Raffaello Gualterotti
### Italian, 1543-1639

**31.** *Guioco del Calcio - Piazza Santa Croce, Florence* (SN 36)
    Oil on canvas,
    34½ x 45¾ in. (87.6 x 116.2 cm.)
**Coll:**  Elia Volpi, Palazzo Davanzati, Florence;
    Elia Volpi sale, AAA, N.Y., Nov. 21-27, 1916, lot 1018 (as Allori);
    with Bernet, N.Y.;
    James Warren Lane sale, AAA, N.Y., Nov. 20, 1924, lot 156 (as Allori);
    Edgar Mills sale, Marx, N.Y., Nov. 11-14, 1930, lot 298 (as Bronzino);
    acquired Ringling Bequest, 1936.
**Lit:**  Tomory, 1976, no. 20.
    **Plate 5**

This highly unusual painting was first given by Suida to Gualterotti, a Florentine artist known only for his designs for Medici wedding festivals in 1579 and 1589. The basis for the association is an engraving by Baldi and Marsili after a design by this artist in *Feste nelle nozze del . . . Francesco Medici . . . e . . . Biana Cappelli* (1579); in fact, Gualterotti also prepared the two books describing the Medici wedding of 1589. As no other painting seems to be known by this artist, the attribution to him can only be provisional. Tomory, rightly noting a connection with Allori, observes that the horsemen are taken almost unchanged from an engraving of the War of Siena by Stradanus for the series *Medicae Familiae Rerum Feliciter Gestorum Victoriae et Tiumphi*, Florence, 1583.

The game depicted in the picture is the Giuoco del Calcio, the traditional Florentine football game played annually and on special occasions by young men from upper class families in the Piazza Santa Croce. Each team had twenty-seven men:

fifteen *innanzi* (linemen), five *sconciatori* (quarterbacks), four *datori innanzi* (halfbacks), three *datori addietro* (fullbacks). In this painting the game has been started by the *pallaio* throwing the ball into the nearest of the three *quadriglie* of linemen. Each team then tried to kick or punch the ball towards the opposing goal line. A game would last about an hour. A marble plaque on the south side of the piazza dated 10 February, 1565, marked the halfway line for the game.

### Frans Hals
Dutch, 1585-1666

**32.** *Portrait of Pieter Jacobsz. Olycan* (SN 251)

Oil on canvas,
43¾ x 34⅟₁₆ in. (111.1 x 85.6 cm.)

**Coll:**  Cited in the inventory of Olycan's daughter, Geertruyd,
widow of Jacob Benningh, Haarlem, November 11, 1666;
Sutton Hall, May, 1922;
A. Reyre, London, 1926;
acquired Ringling Bequest, 1936.

**Lit:**  Robinson and Wilson, 1980, no. 83.
**Plate 32**

P.J. Olycan was a brewer, burgomaster and a member of the Dutch States-General, and belonged to a family which helped to administer the city of Haarlem in the seventeenth century.

Hals' portrait of Olycan's wife, Maritge Vooght, which is in the Rijksmuseum, dates from 1639. Hals painted many other members of the Olycan family.

### Jan Davidsz. de Heem
Dutch, 1606-1684

**33.** *Still Life with Parrots* (SN 289)

Oil on canvas,
59¼ x 45¾ in. (150.5 x 116.2 cm.)
Signed, lower left, *F.D. De Heem. f.*

**Coll:**  Counts of Schonborn, Castle of Pommerfelden, catalogues
of 1719 and 1857 (as "a masterpiece by Jan de Heem");
Pommerfelden sale, Paris, May 17-24, 1867, lot 38;
acquired Ringling Bequest, 1936.

**Lit:**  Robinson and Wilson, 1980, no. 84.
**Plate 22**

One of the grandest still life pictures by this Antwerp contemporary of Rubens, it dates from the 1640s. Modern scholars consider that a work of this luxuriant nature may contain a moral message: a warning against waste. Two replicas exist.

### Martin van Meytens
Swedish-Austrian, 1695-1770

**34.** *Portrait of the Empress Maria-Theresia of Austria* (SN 325)

Oil on canvas,
76 x 52 in. (193 x 132 cm.)

**Coll:**  Baronne de Vaux, Paris;
American Art Association, May, 1927, lot 98;
acquired Ringling Bequest, 1936.

**Lit:**  Suida, 1949, no. 325.
**Plate 51**

This Swedish-Austrian artist became the favourite portrait painter at the Court of Vienna. Maria-Theresia (1717-80) married Franz Stephan in 1736, was crowned Queen of Hungary in 1741 and Queen of Bohemia in 1743.

On a table at the left are seen the Austrian *Herzoghut*, the so-called *Hauskrone* of the Hapsburg Emperors (made for the Emperor Charles IV) and the *Stephanskrone* of Hungary.

**35.** *Portrait of the Emperor Francis I* (SN 326)

        Oil on canvas,
        76 x 52 in. (193 x 132 cm.)
        **Plate 52**

Franz Stephan of Lorraine (1708-65) was crowned Holy Roman Emperor in October, 1745. He is depicted wearing the Golden Fleece. The crown of the Holy Roman Empire (made for Conrad II) and the *Reichsaptel* are on the table.

A pendant to no. 34.

## Giovanni Battista Moroni
### Italian, active 1546-1578

**36.** *Portrait of Mario Benvenuti* (SN 106)

        Oil on canvas,
        45⅞ x 36 in. (115.9 x 91.4 cm.)
        Inscribed on pillar: *MARIUS BENVE. TU/SUB. CARLO V/IMPERAT. RE DUX*

  **Coll:**    Prince of Orange, Brussels, after 1816;
        King of Holland, sale, Amsterdam, August 12-19, 1850 (?);
        Chaplin;
        Thomas Baring, 1851;
        Earl of Northbrook by 1889;
        with R. Langton Douglas, 1927;
        anon. sale, Christie's, June 28, 1929, lot 52;
        acquired Ringling Bequest, 1936.
  **Lit:**     Tomory, 1976, no. 57.
        **Plate 8**

Nothing is known about the sitter, except that he served as a military commander under Charles V. Tomory dates this well-preserved picture to 1560 on the basis of a comparison with the signed and dated *Portrait of a Man* in the Pinacoteca, Brescia. It shares certain features with *Portrait of a Gentleman* in the National Gallery, London (no. 1316).

Since the publication of Tomory's catalogue, this painting has been studied by Mina Gregori *(Giovanni Battista Moroni,* in *I Pittori Bergamaschi,* 1979, no. 188, p. 302, repr. p. 342) who confirms the dating to around 1560 and points out stylistic relationships with other pictures of the period. She quotes an oral communication with Dr. Rossi to the effect that the armour indicates that the sitter was the commander of territorial soldiers in the local defence force.

## Giovanni Paolo Panini
### Italian, 1691-1765?

**37.** *Hermes Appears to Calypso* (SN 171)

        Oil on canvas,
        50 x 63 in. (128 x 160 cm.)
        Inscribed: *JO Paolo Panini f. Romae*

  **Coll:**    First Lord Bateman, Sobdon Court, Herefordshire;
        with Newman, London;
        purchased by John Ringling, c. 1926-30;
        acquired Ringling Bequest, 1936.
  **Lit:**     Tomory, 1976, no. 145
        **Plate 35**

The subject of this painting and its pendant (no. 38) is Homer's *Odyssey*. F. Arisi in his book on the artist (1961) dates both pictures to early in Panini's career, c. 1718-19 when he was engaged on the decoration of the Villa Patrizi.

**38.** *Circe Entertains Odysseus at a Banquet* (SN 172)

Oil on canvas,
50 x 63 in. (128 x 160 cm.)
Inscribed: *JO Paolo Panini f. Romae*
**Plate 36**

A pendant to no. 37.

## Nicolas Poussin
### French, 1594(?)-1665

**39.** *The Holy Family* (SN 361)

Oil on canvas,
76 x 50½ in. (193 x 128.3 cm.)

**Coll:** Duke de Créqui (?), French Ambassador to Rome, 1661;
Pointel;
Sir Richard Worsley;
Earl of Yarborough, sale, Christie's, July 12, 1925, lot 70;
purchased by John Ringling through Böhler, Münich;
acquired Ringling Bequest, 1936.

**Lit:** Suida, 1949, no. 361.
**Plate 30**

The date of this painting, 1655, is known from the reference in Poussin's letters (*Correspondence . . .*, 1911, p. 437) to his having executed a picture for an "important person". This was perhaps the Duke de Créqui, French Ambassador to Rome, during the anti-French disturbances. The artist later offered it to Madame de Montfort (later Madame de Chantelme) but rescinded the offer.

The picture demonstrates the classical serenity of the artist's later style and is one of the last four of Poussin's Holy Families which are at Karlsruhe and Toledo; the remaining one is known only through an engraving by Sebastien Vouillement.

## Adam Pynacker
### Dutch, 1622-1673

**40.** *Landscape with Hunters* (SN 896)

Oil on canvas,
32¼ x 27¾ in. (82 x 70.5 cm.)
Signed, lower left: *A Pynacker*

**Coll:** Swedish private collection;
J.H. Galloway, Ayr, Scotland, 1925;
Leonard Koetser Ltd., London;
H. Shickman Gallery, N.Y.;
acquired, 1971.

**Lit:** Robinson and Wilson, 1980, no. 113,
**Plate 34**

This example of Pynacker's later work, datable to about 1670, provides eloquent testimony to the way in which his experiences of Italy haunted his imagination. F.W. Robinson rightly draws attention to the almost rococo character of the border of the branches and grass that frames the composition. Two copies by later hands exist.

### Salvator Rosa
Italian, 1615-1673

**41.** *Allegory of Study* (SN 152)

Oil on canvas,
54⁵⁄₁₆ x 38⅜ in. (136 x 95 cm.)
Engraved by John Neagle, 1807;
Richard Cooper, 1824 (frontispiece to Lady Morgan's *Life*).

**Coll:** Unknown Italian collection (c. 1759-63);
First Earl Grosvenor;
by inheritance Duke of Westminster;
sale, Christie's, July 4, 1925, no. 38;
with Leyton;
bought by John Ringling, 1925;
acquired Ringling Bequest, 1936.

**Lit:** Tomory, 1976, no. 165.

**Plate 13**

Suida was the first to reject the identification of this painting as being a self-portrait; it is now considered to be an *Allegory of Study*, of which the subject is derived from Ripa's *Iconologia*, 1603 p. 478. Ripa's quotation, which he gives as from Juvenal, but which is from Persius, reads: "But your delight is to grow pale over nightly study".

Salerno dates the painting to c. 1649, just prior to the artist's departure from Florence for Rome. A variant was in the Italian art trade in 1968.

### Peter Paul Rubens (and studio)
Flemish, 1577-1640
### Osias Beert the Elder
Flemish, c. 1580-1624

**42.** *A Scholar Inspired by Nature* (SN 219)

Oil on canvas,
80 x 76½ in. (203.2 x 194.3 cm.)

**Coll:** Sir Gregory Page, Wricklemarsh, Blackheath, Kent, died 1775;
Sir Gregor Page Turner;
van Heythusen;
Welbore Ellis Agar, sale, Christie's, May 2, 1806, 1,000 guineas;
Second Earl of Grosvenor, later First Marquess of Westminster;
Duke of Westminster;
Westminster sale, Christie's, July 4, 1924, lot 41;
acquired Ringling Bequest, 1936.

**Lit:** Robinson and Wilson, 1980, no. 40.

**Plate 18**

The old titles, "Rubens and his Wife" and "Pausias and Glycera", the second of which was coined by Waagen, have been abandoned (Wilson) in favour of the present one; however, the picture may represent the artist's brother, Philip and his wife Maria de Moy (Wilson).

The painting is generally dated to 1612-15. It is not entirely autograph, though the vividly executed heads are by the master. Ingvar Bergström has convincingly argued that the flowers are by Osias Beert the Elder and not by Jan Breughel.

## Peter Paul Rubens
### Flemish, 1577-1640

**43.** *Achilles Dipped into the River Styx* (SN 221)

 Oil on panel,
 43¹⁄₁₆ x 35⁵⁄₁₆ (109 x 89.5 cm.)

**Coll:** Daniel Fourment, Antwerp, until June, 1643;
 Peter Fourment, Antwerp, until April 18, 1653;
 Gerard van der Strecken,
 Jan van Leefdael,
 Hendrick Lenaerts, Brussels;
 Kings of Spain;
 Dukes of Infantado, Madrid (inventory Pastrana
 c. 1754-1800, as *La noche cuando immortalizaron a Aquiles*),
 until November 27, 1841;
 Duke of Pastrana, Madrid;
 Duchess of Pastrana, Madrid;
 Communudad de las Religiosas del Sagrado Corazon de Jesus, Madrid, c. 1887;
 Emile Pacully sale, Georges Petit, Paris, May 4, 1903, lot 28;
 John E. Stillwell sale, Anderson Galleries, N.Y., December 1-3, 1927, lot 224;
 purchased by Kleinberger Galleries for William R. Hearst, N.Y.;
 returned by Hearst to Kleinberger, 1929 in payment for another painting;
 purchased by John Ringling in 1930;
 acquired Ringling Bequest, 1936.

**Lit:** Robinson and Wilson, 1980, no. 39.
 **Plate 19**

This is a *modello* for the first of the series, "The History of Achilles", which is the last of the five tapestry commissions designed by Rubens, and which dates from after 1630 and before 1635. The series was commissioned, not by Charles I, as was once believed, but by the painter's father-in-law, Daniel Fourment. The tapestries, the *bozzetti* and probably also the *modelli* are listed in an 1643 inventory of the Fourment company.

The *modelli* are distributed between the Prado (three) the Seilern Collection, London (two) and the Musée des Beaux-Arts, Pau (two). The *bozzetti* are in the Boymans-van Beuningen Museum, Rotterdam except for one in the Detroit Art Institute. Ludwig Burchard (*Catalogue of a loan exhibition of works by Sir Peter Paul Rubens*, Wildenstein, London, 1950, no. 13) maintained that the *modelli* were painted by Rubens. E. Havercamp-Begemann (*The Achilles Series, Corpus Rubenianum*, 1975, no. 1b) considers that in this picture the "visible surface" seems "largely the work of Rubens himself".

Julius Held in his recently published *The Oil Sketches of Rubens*, 1980, I, p. 173, considers that the work is essentially a product of the studio, though Rubens "may have touched up the main figures". A few variants occur between the Sarasota and the Rotteram picture; for instance, the breast of the woman holding the torch is exposed in the former work.

A tapestry of this subject from a later seventeeth-century edition by J. Rees is in the Cathedral of Santiago de Compostela, Spain.

**44.** *Portrait of the Archduke Ferdinand* (SN 626)
Oil on canvas,
45¾ x 37 in. (116.2 x 94 cm.)

**Coll:**   Purchased by Sir Joshua Reynolds in 1771 for 100 guineas;
The Earl of Upper Ossory;
Robert Vernon, First Baron Lyveden;
The Hon. Greville Richard Vernon;
purchased by J. Pierpont Morgan in 1898, Dover House, London;
with Knoedler, N.Y.;
acquired, 1948.

**Lit:**   Robinson and Wilson, 1980, no. 34.
**Plate 20**

This fluently handled picture is a state portrait of the Archduke Ferdinand who when twenty-six years old sat to Rubens in 1635. The Archduke was the brother of the King of Spain and was made a Cardinal at the age of ten. He defeated the Swedes in the Battle of Nördlingen in 1634 and arrived in Antwerp in 1635 to assume the Governorship of the Netherlands as a successor to his aunt, the Archduchess Isabella. He is depicted wearing essentially the same costume as in the equestrian portrait in the Prado, the *modello* for which is in the Art Institute of Detroit.

## Sassoferrato (Giovanni Battista Salvi)
Italian, 1609-1685

**45.** *Portrait of Cardinal Paolo Emilio Rondinini (1617-1678)* (SN 128)
Oil on canvas,
87 x 64 in. (221 x 162.5 cm.)

**Coll:**   Viscount Ridley (before 1911);
by inheritance Bromley-Davenport;
sale, Christie's, July 28-29, 1926, lot 116 (as Maratta);
with Martin;
acquired Ringling Bequest, 1936.

**Lit:**   Tomory, 1976, no. 150.
**Plate 12**

The identity of the sitter as Cardinal Paolo Emilio Rondinini was proposed by E.K. Waterhouse by comparison with an engraved portrait in G. Rossi's *Effigies, insignia . . . cardinalium defuncto ab anno MDCLVIII*, plate 23. Rondinini was Treasurer to the Vatican during the War of Castro, 1642, and was elevated to Cardinal for his services in 1643. Tomory notes a connection between this portrait and Velasquez's *Portrait of Innocent X* in the Doria Pamphili Gallery, Rome, of 1650; for him it seems feasible to suggest that Sassoferrato "was inspired to compete with another symphony of reds" and thus he proposes a date for the picture of c. 1651. The *Madonna and Child* by Sassoferrato shown in the picture is in the collection of the Marquess of Exeter, Burghley House, Stamford.

## Jacopo del Sellaio
### Italian, c. 1441-1493

**46.** *The Penitent St. Jerome* (SN 17)
        Panel,
        13½ x 12½ in. (33.3 x 30.7 cm.)
  **Coll:**   Emile Gavet, Paris;
        William K. Vanderbilt;
        Mrs. Oliver Belmont, Newport, R.I.;
        purchased by Ringling through Duveen, 1928-29;
        acquired Ringling Bequest, 1936.
  **Lit:**    Tomory, 1976, no. 32.
        **Plate 3**

Tomory considers that this painting and *St. John the Baptist* in the National Gallery, Washington, D.C. (no. 394) might have belonged to the same predella panel. Fern Rusk Shapley, in *Catalogue of the Italian Paintings,* National Gallery of Art, 1979, p. 425, plate 304, makes no reference to this proposed connection. Her argument against linking the Washington panel with a Sellaio panel of *David with the Head of Goliath* in Philadelphia has to do with the disparity of figure sizes in comparison with the backgrounds. The same argument would hold for the Ringling panel where the figure of St. Jerome is much smaller than the National Gallery St. John the Baptist.

## Juriaen van Streeck
### Dutch, 1632-1687

**47.** *Still Life with Fruit* (SN 290)
        Oil on canvas,
        27⅜ x 21½ in. (69.5 x 57.2 cm.)
        Signed: *J.v. Streek/f.*
  **Coll:**   Acquired Ringling Bequest, 1936.
  **Lit:**    Robinson and Wilson, 1980, no. 121.
        **Plate 23**

A characteristic example of this Amsterdam still life painter's subtle painting in which the items represented would have appealed to his admirer's collecting instincts. These are a nautilus shell from the Indian ocean with silver mounts, a Baroque silver plate and a Chinese (or Delft imitation) pitcher with pewter mounts and an elegant carpet. These elements may be found in other works by this painter.

## Bernardo Strozzi
### Italian, 1581-1644

**48.** *An Act of Mercy: Giving Drink to the Thirsty* (SN 634)
        Oil on canvas,
        52¼ x 74⁹⁄₁₆ in. (132.7 x 189.4 cm.)
  **Coll:**   Fleischauer sale, Stuttgart, April 24-25, 1928 (?);
        Bruno Kern;
        with Galerie Sanct Lucas, Vienna, 1937;
        Oskar Bondy, 1949;
        with Weitzner, N.Y., 1950;
        acquired, 1950.
  **Lit:**    Tomory, 1976, no. 62.
        **Plate 15**

The suggestion has been made that this picture, which probably dates from c. 1620, is one of a series of six paintings, constituting a series of "Seven Acts of Mercy", but it is more likely to be a pendant to *Elijah and the Widow of Zaraphath* in the Kunsthistorisches Museum, Vienna. The Ringling and Vienna pictures were possibly painted for the Carmelite Order.

A red chalk drawing for the arm and crutch was with the Shickman Gallery, N.Y.

## Diego Velazquez
### Spanish, 1599-1660

**49.** *Philip IV, King of Spain* (SN 336)

Oil on canvas,
82 x 47 in. (205 x 117.5 cm.)

**Coll:** The Prince of Orange, Brussels, 1833;
Nieuwenhuys, 1853;
Robert Holford;
Sir George Holford, sale, Christie's, May, 1928;
acquired Ringling Bequest, 1936.

**Lit:** Suida, 1949, no. 336.
**Plate 26**

This full-length portrait of the Spanish monarch which was seen by J.D. Passavant on his tour of England (*Kunstreise,* 1833, p. 394) has not been studied in depth. It appears in the old standard volumes of Curtis (1883) and Justi (1889) as being by the master. Allende Salayar (2nd edition of *Velasquez, Klassiker der Kunst,* 1925), who had not seen it, doubted it and A.L. Mayer (1935) believed it to be a "fine studio picture". Suida supported it as an original, c. 1627. Although rejected by José Lopez-Rey (1963) as being "derivative", J.M. Soria claimed that it was in part by the artist; J. Gudiol (1973, no. 45) considers it to be by Velazquez, belonging to the close of his first Madrid period and probably dating to 1628. This view was rejected by Lopez-Rey in his review of Guidol's volume (*Gazette des Beaux-Arts,* January, 1974).

To accord with the King's age, this picture would have had to have been painted about 1628-29; it may be compared with the portraits in the Prado and Metropolitan. The nearest in point of view of features is in the Prado in which Philip is shown wearing armour. On the basis of x-rays and the c. 1960 cleaning, it is clear that the artist's first intention was to present the King in armour. There is no exemplar which shows Philip wearing campaign dress as he does in this portrait. The quality of the painting in certain areas (the sash, the sleeves and the face) appears sufficiently high to indicate that the painting is a studio work in which the master intervened.

## Paolo Veronese
### Italian, c. 1528-1588

**50.** *The Rest on the Flight into Egypt* (SN 82)

Oil on canvas,
92¼ x 63¼ in. (234.3 x 160.6 cm.)

**Coll:** Electoral Gallery, Dusseldorf, by 1719;
Alte Pinakothek, München, by 1836;
with Julius Böhler, c. 1925-26;
acquired Ringling Bequest, 1936.

**Lit:** Tomory, 1976, no. 124.
**Plate 7**

The discovery by Richard Cocke of a drawing after this picture by Veronese's son Benedetto Caliari in the Boymans-Van Beuningen Museum, Rotterdam, which is dated 1570-71, suggests that it would have been painted just before then. The influence of Titian and of Dürer's woodcuts (first referred to by Ridolfi in *Le Meraviglie . . .*) may be noted in this sumptuous example of Cinquecento Venetian painting.

### Claude Vignon
French, 1593-1670

**51.** *Banquet of Anthony and Cleopatra* (SN 653)

        Oil on canvas,
        34¼ x 44¼ in. (81.9 x 112.4 cm.)

**Coll:**  Acquired from Vitale Bloch, 1951.

**Lit:**  Vitale Bloch, "Claude Vignon", *Maandblad voor Beeldende Kunsten*,
       July, 1947, pp. 158ff., repr. p. 160.

       **Plate 29**

Another painting of the same subject is in the Wadsworth Atheneum, Hartford.

### Simon Vouet
French, 1590-1649

**52.** *Venus, Mars, Cupid and Chronos* (SN 360)

        Oil on canvas,
        57½ x 42½ in. (146 x 108 cm.)

**Coll:**  Purchased by John Ringling, c. 1926-30 (as unknown Italian artist);
       acquired Ringling Bequest, 1936.

**Lit:**  Suida, 1949, no. 360.

       **Plate 28**

Although Willian Crelly (*The Paintings of Simon Vouet,* 1962, no. 13a) published this painting as being by Vouet, he did so with some reservation, which he subsequently withdrew.

It dates from the late 1630s or early 1640s, and may be compared to *Holy Family with Saint Elizabeth and Infant St. John* (Earl of Wemyss and March), of c. 1635-39, and *Time Vanquished by Hope, Love and Beauty* (Musée de Bourges), c. 1639-45 in which the figure of Time bears a resemblance to that in the Ringling picture. The painting at Bourges was one of a set decorating a room in the Hotel de Bretonvilliers, Paris, to which d'Argenville refers in his *Voyage de Paris*, 1768, p. 231. However, the Ringling painting does not seem to be related to this cycle, although it presumably belongs to a similar one depicting the fluctuating fortunes of Time and Love.

# Plates

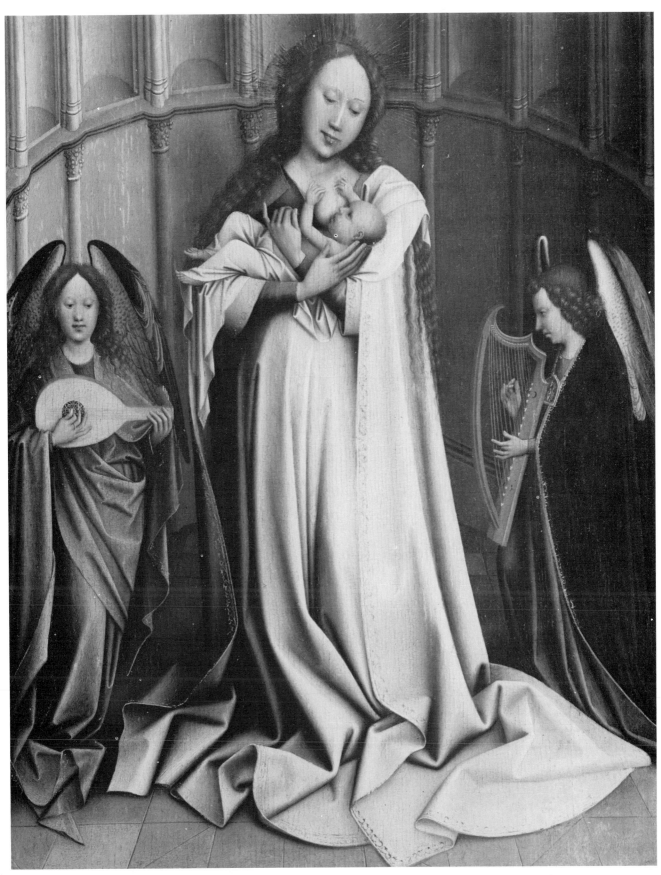

1. After **Robert Campin**
*Virgin and Child in an Apse*

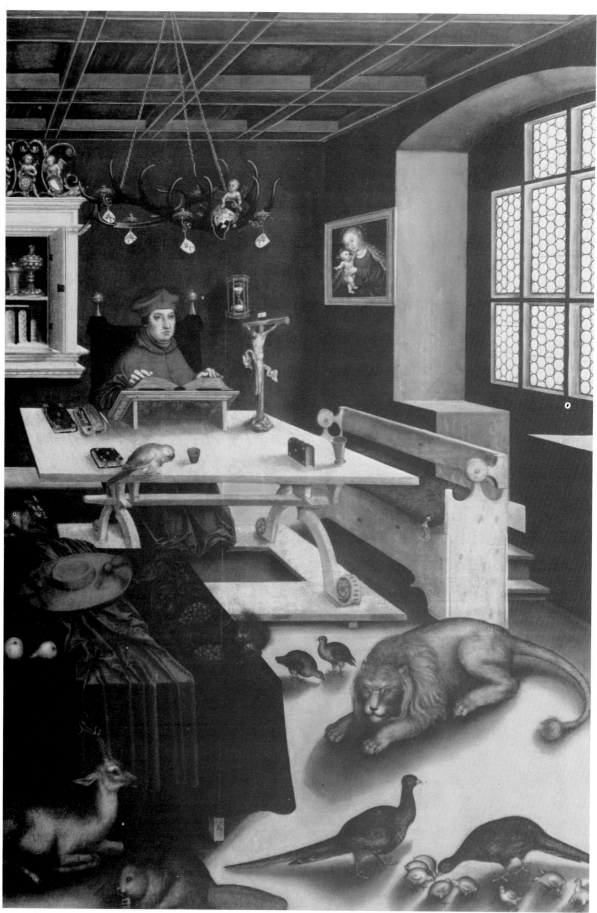

## 2. Lucas Cranach the Elder
*Cardinal Albrecht of Brandenburg as St. Jerome*

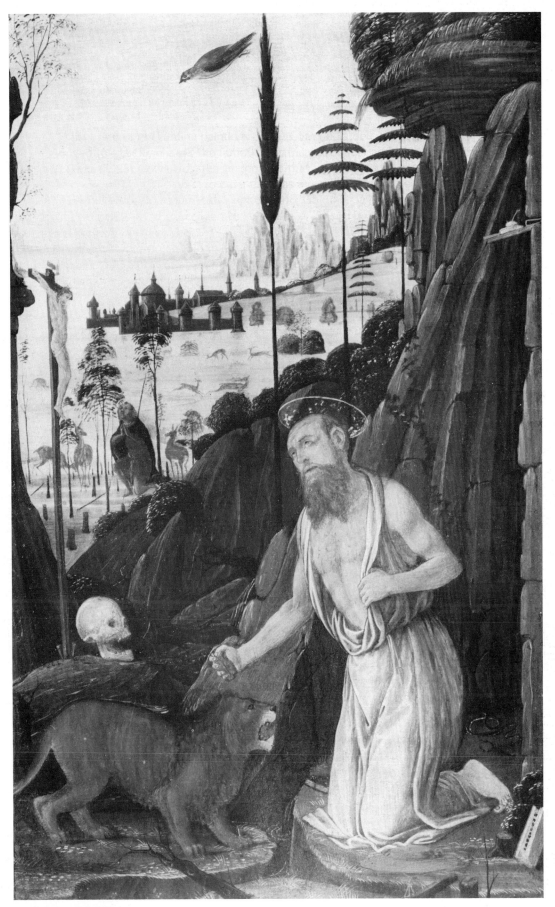

**3. Jacopo del Sellaio**
*The Penitent St. Jerome*

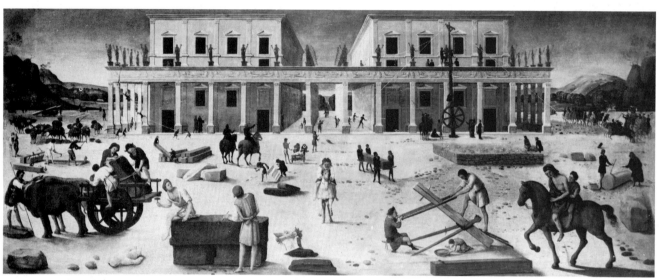

4. **Piero di Cosimo**
*The Building of a Palace*

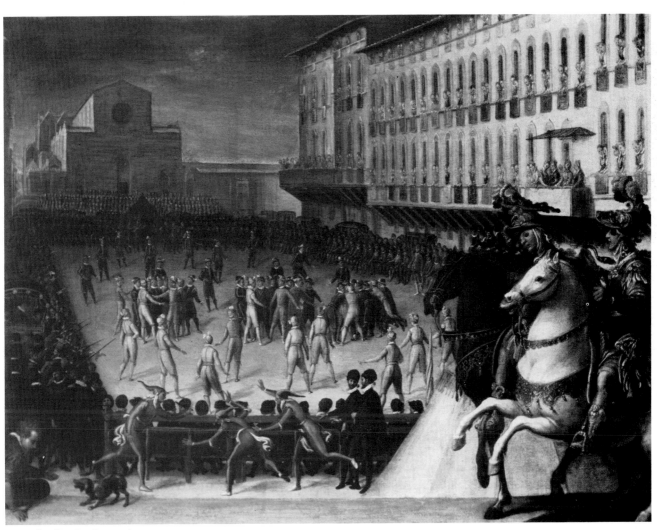

5. **Raffaello Gualterotti**
*Giuoco del Calcio - Piazza Santa Croce, Florence*

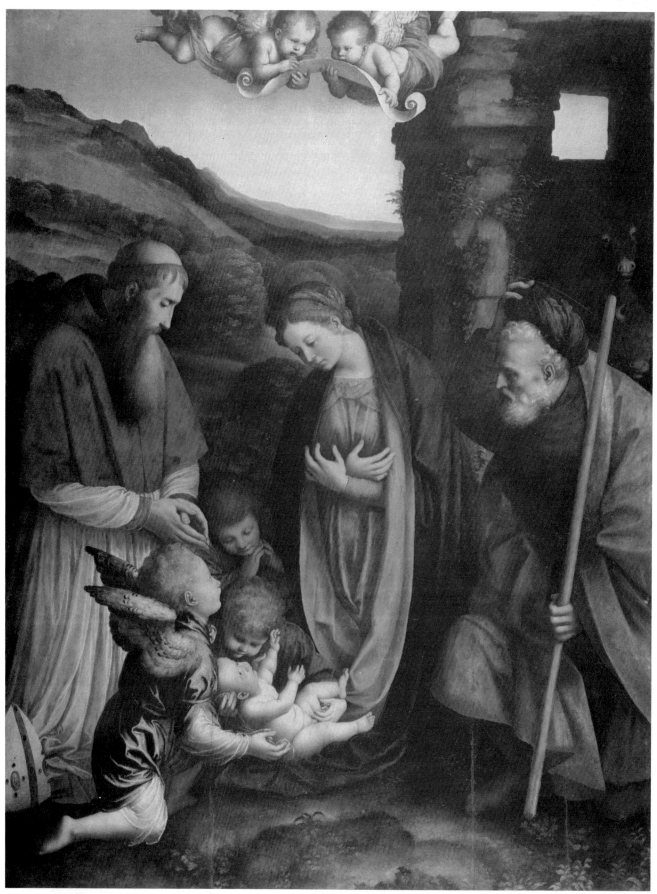

**6. Gaudenzio Ferrari**
*The Holy Family with a Donor*

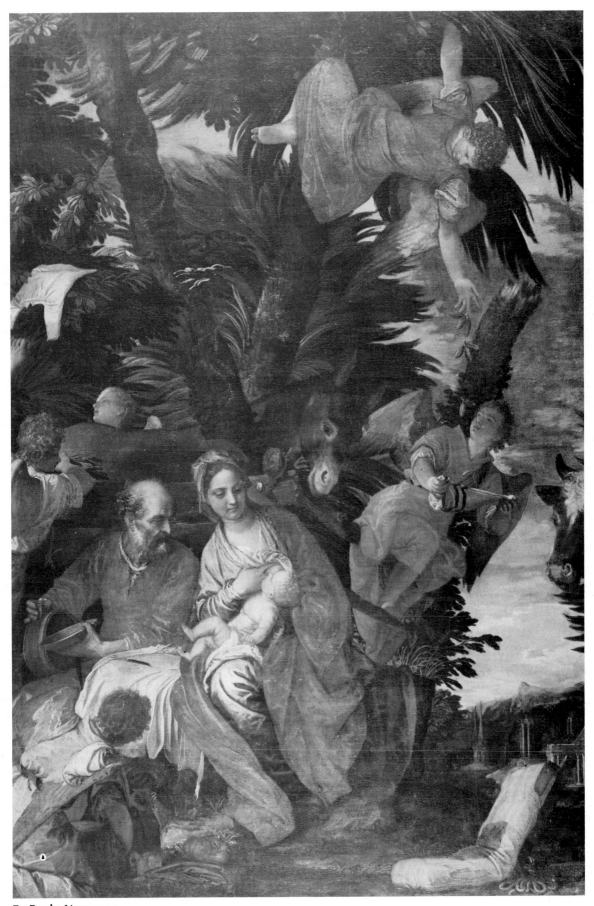

**7. Paolo Veronese**
*The Rest on the Flight into Egypt*

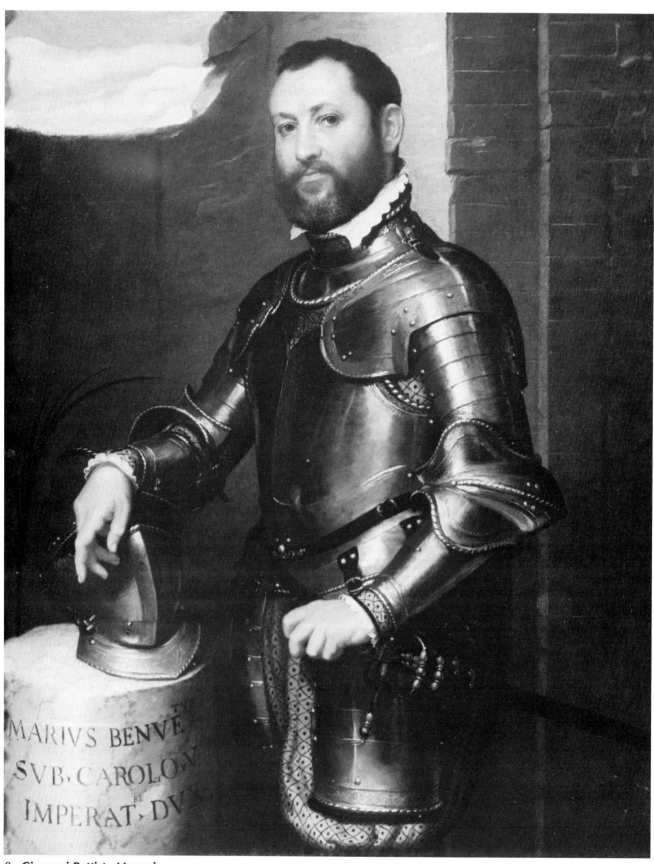

MARIVS BENVE̅
SVB, CAROLO·
IMPERAT·DVX

8. **Giovanni Battista Moroni**
*Portrait of Mario Benvenuti*

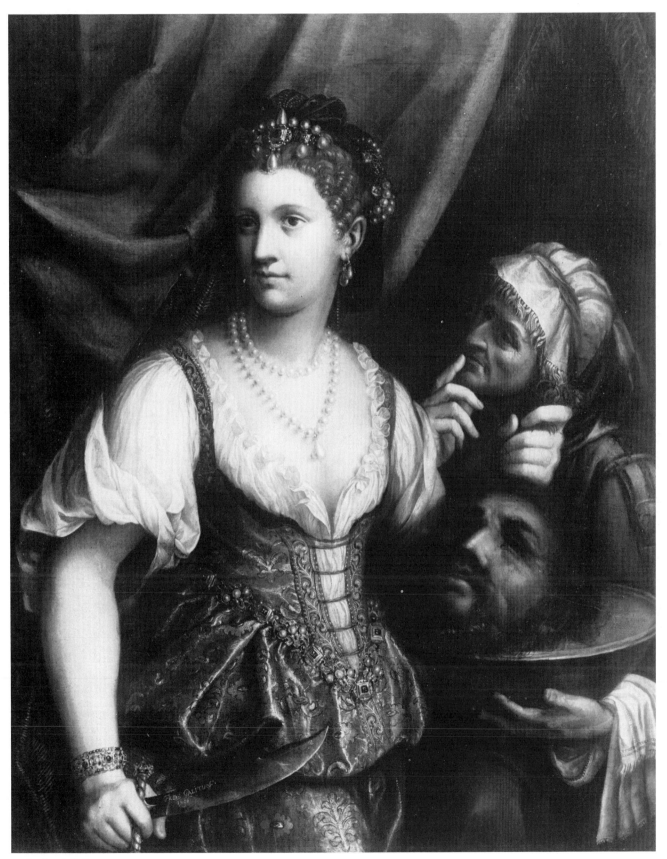

9. **Fede Galizia**
*Judith with the Head of Holofernes*

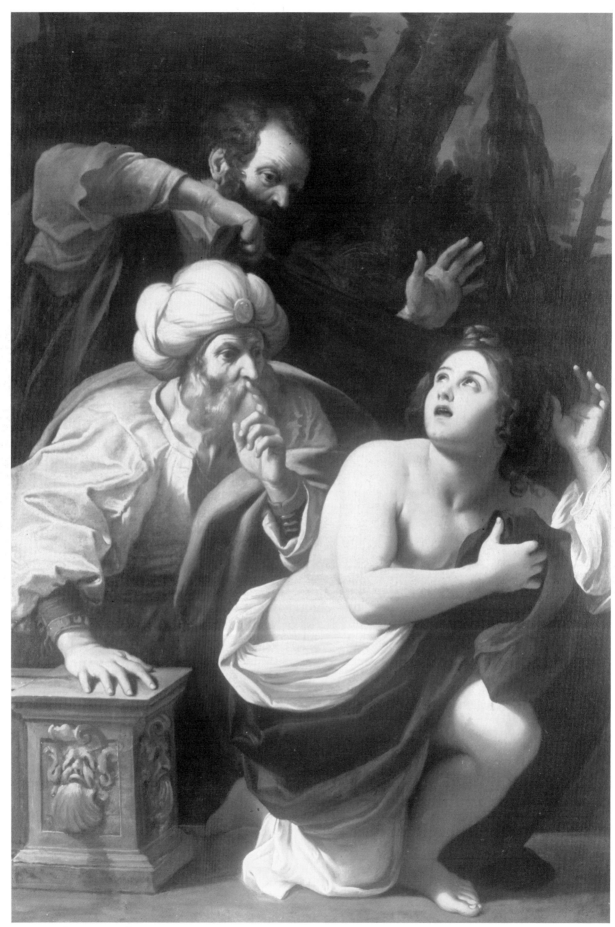

10. **Agostino Carracci**
*Susanna and the Elders*

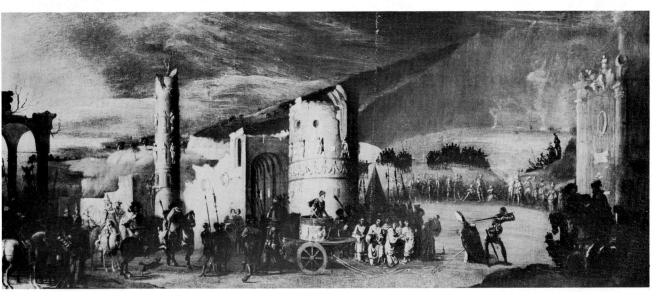

11. **Francesco Desiderio** (Francois Didier Nomé)
*Martyrdom of St. Januarius*

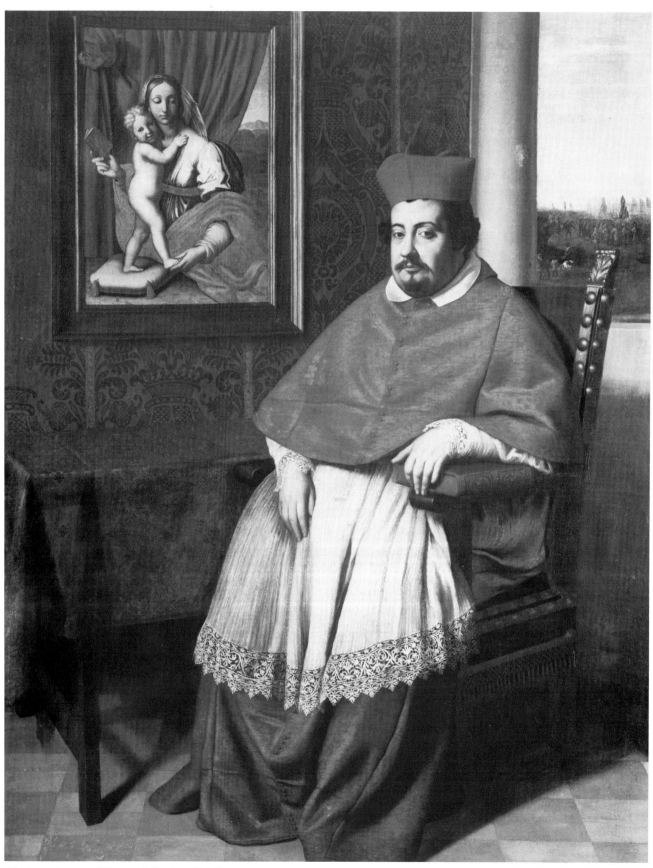

12. **Sassoferrato** (Giovanni Battista Salvi)
*Portrait of Cardinal Rondinini*

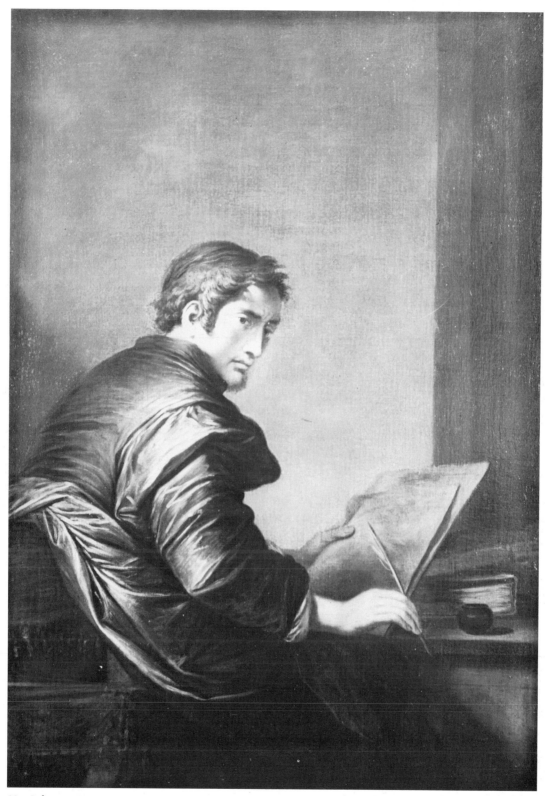

13. **Salvator Rosa**
*Allegory of Study*

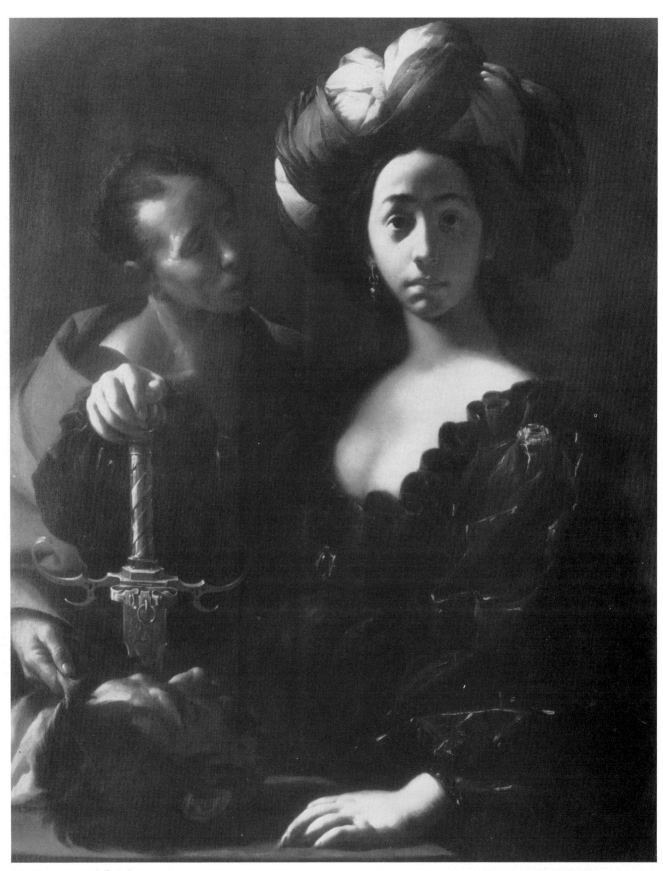

14. **Francesco del Cairo**
*Judith with the Head of Holofernes*

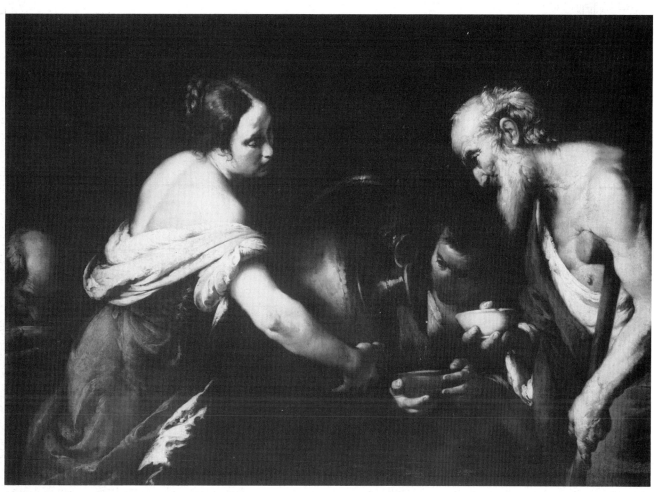

15. **Bernardo Strozzi**
*An Act of Mercy: Giving Drink to the Thirsty*

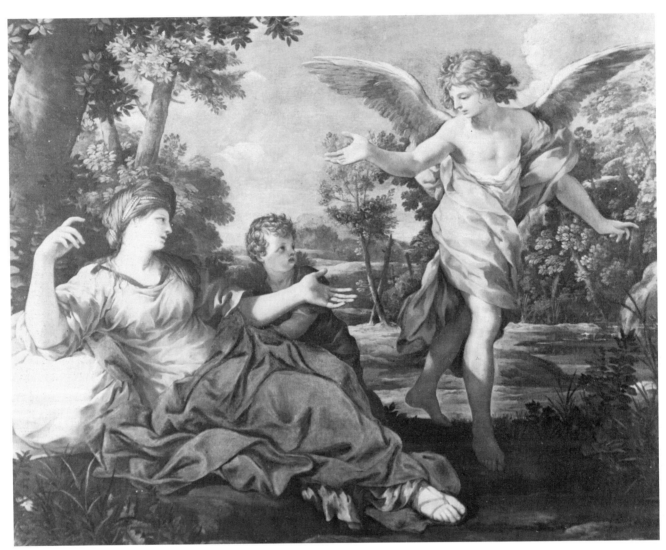

16. **Pietro da Cortona**
*Hagar and the Angel*

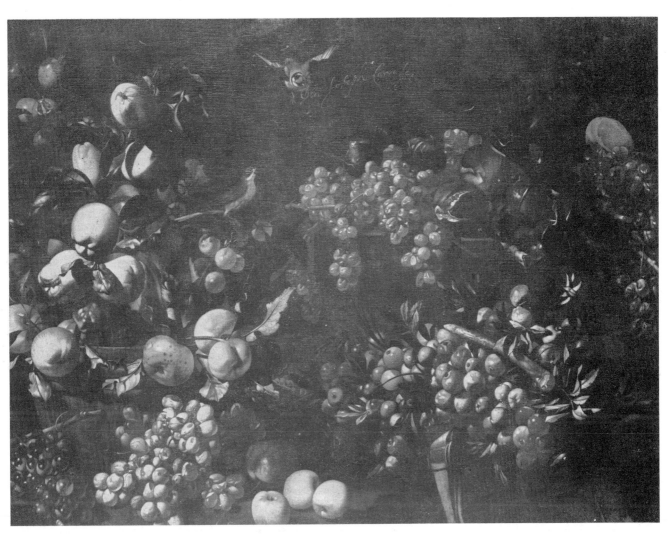

**17. Luca Forte**
*Still Life with Fruit*

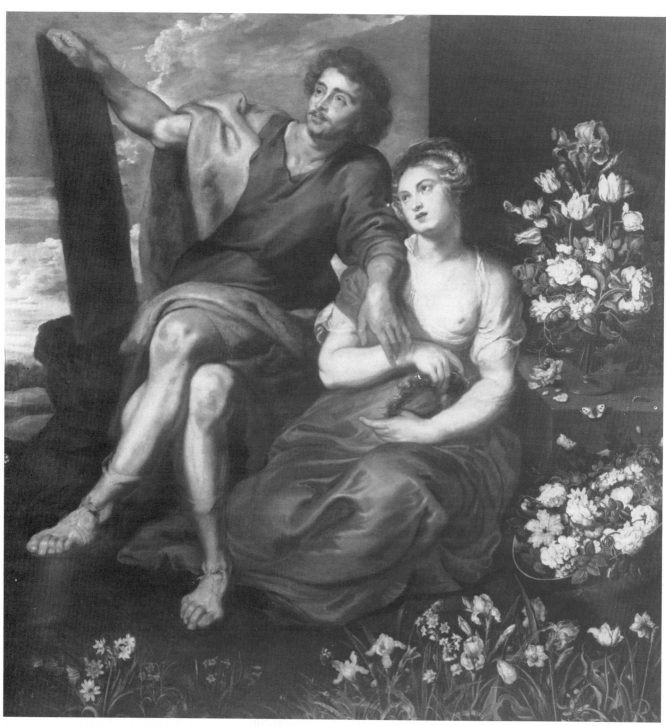

18. **Peter Paul Rubens** (and studio)
*A Scholar Inspired by Nature*

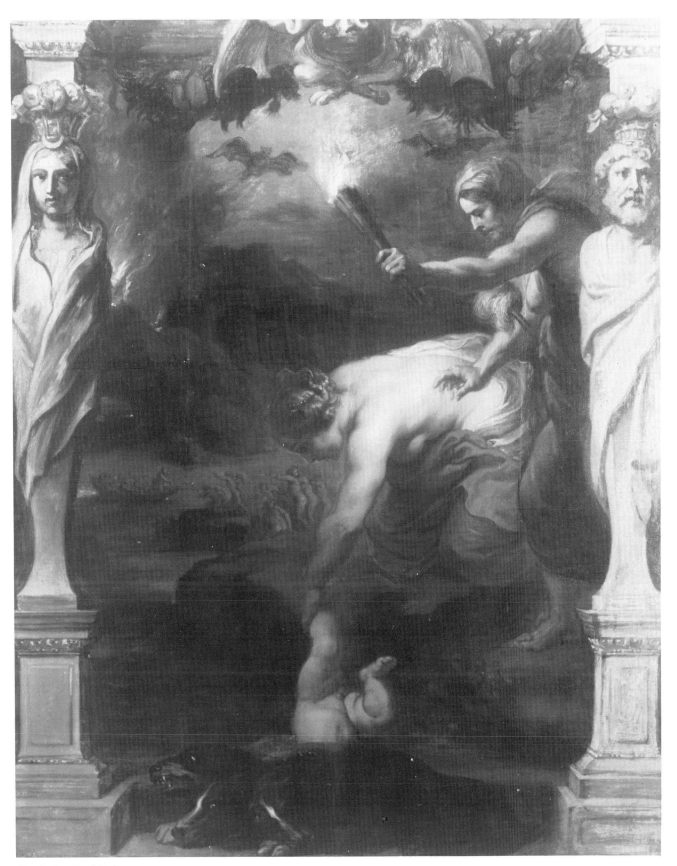

**19. Peter Paul Rubens**
*Achilles Dipped into the River Styx*

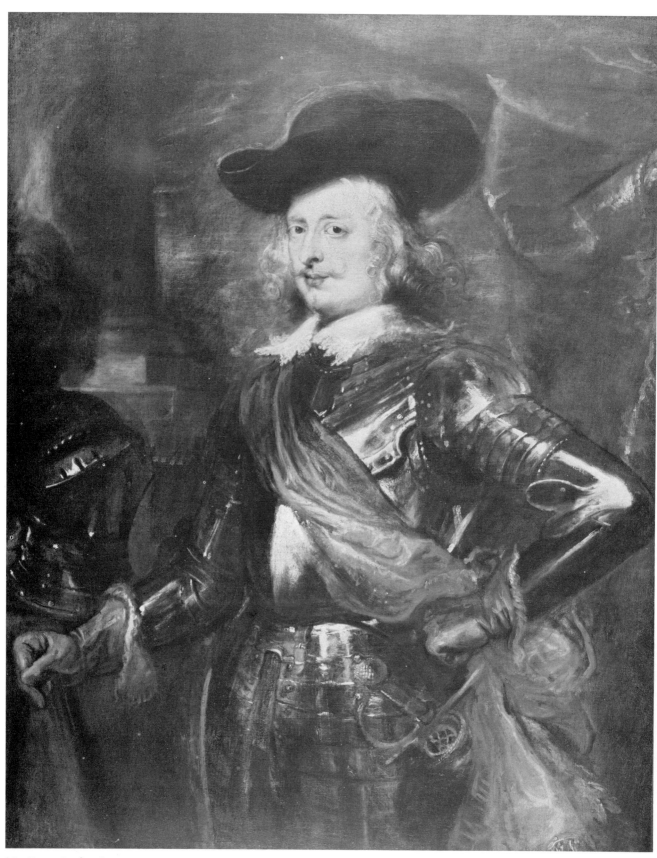

**20. Peter Paul Rubens**
*Portrait of the Archduke Ferdinand*

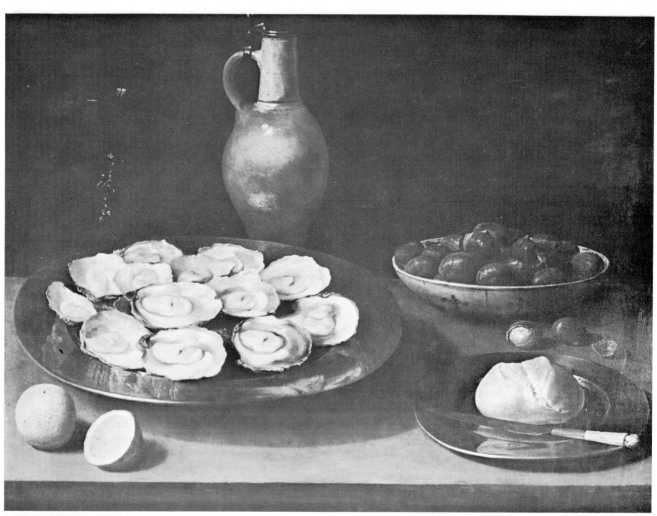

21. **Jacob van Es**
*Still Life with Oysters*

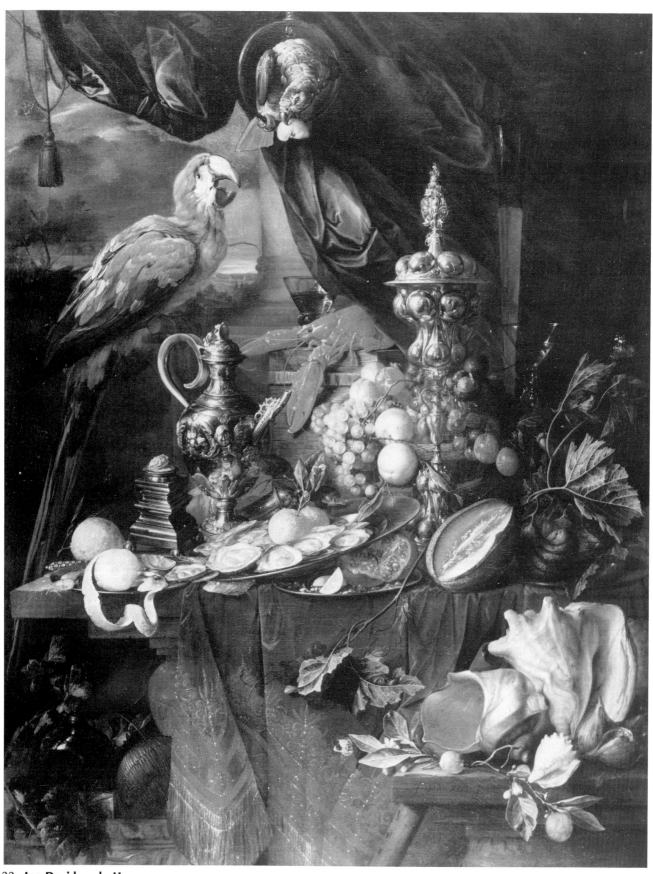

**22. Jan Davidsz. de Heem**
*Still Life with Parrots*

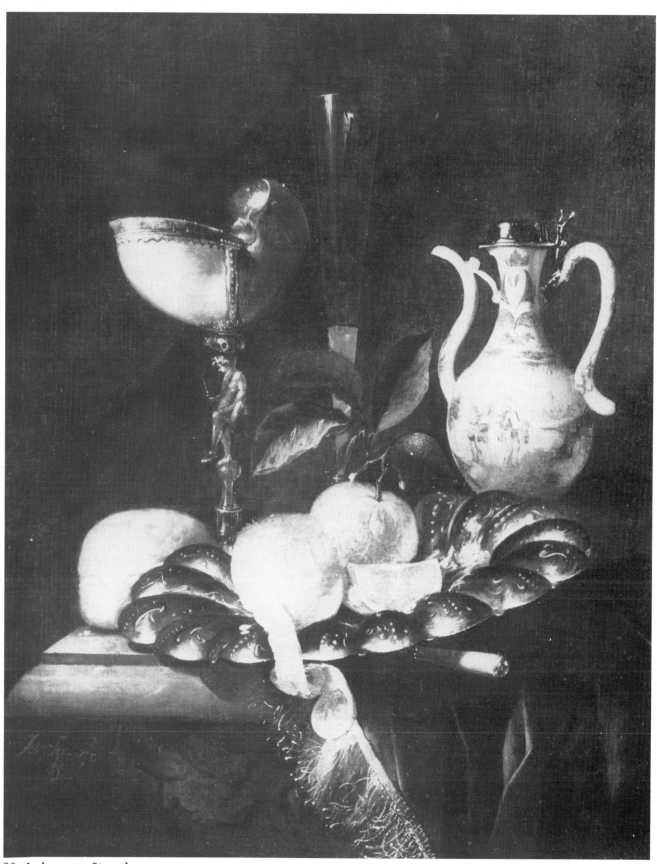

**23. Juriaen van Streeck**
*Still Life with Fruit*

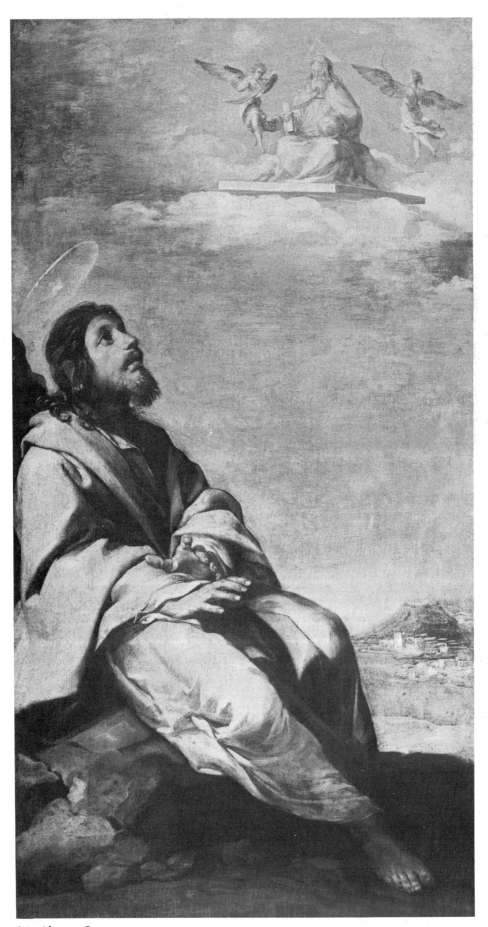

## 24. **Alonso Cano**
*St. John the Evangelist's Vision of God*

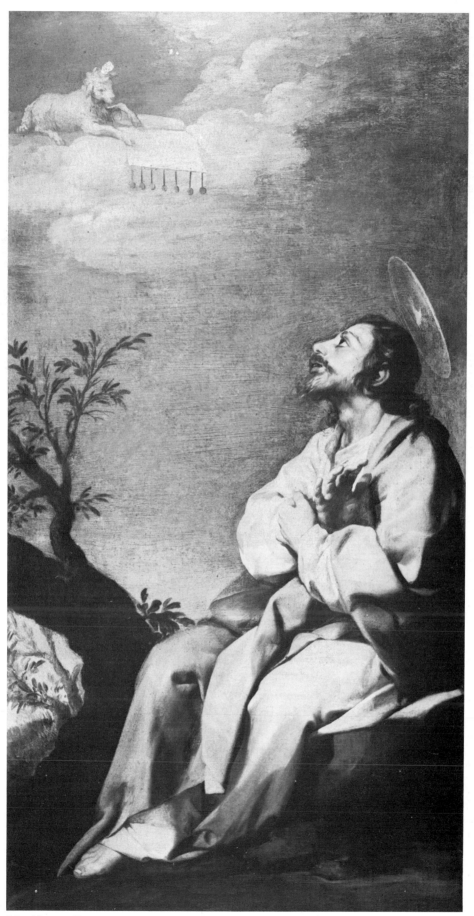

25. **Alonso Cano**
*St. John the Evangelist's Vision of the Lamb*

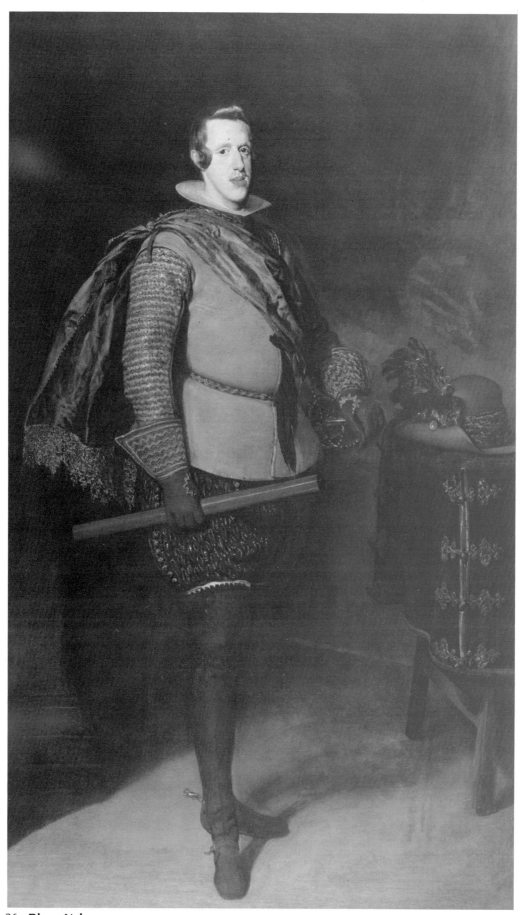

**26. Diego Velazquez**
*Philip IV, King of Spain*

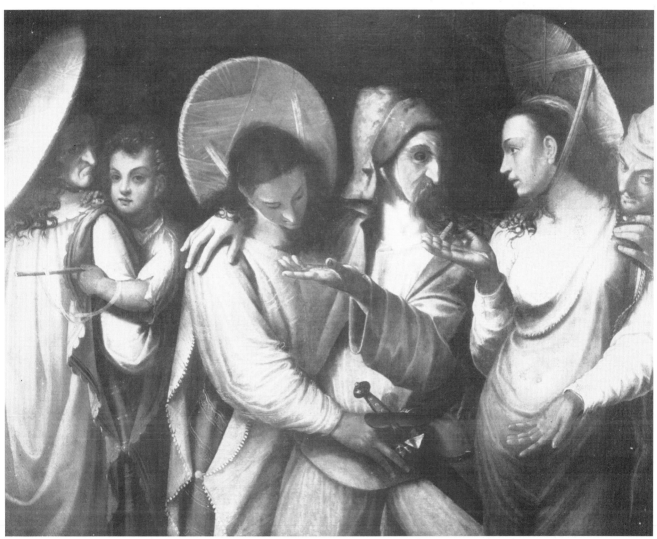

27. Anonymous French Artist
*Scene from the Commedia dell'Arte*

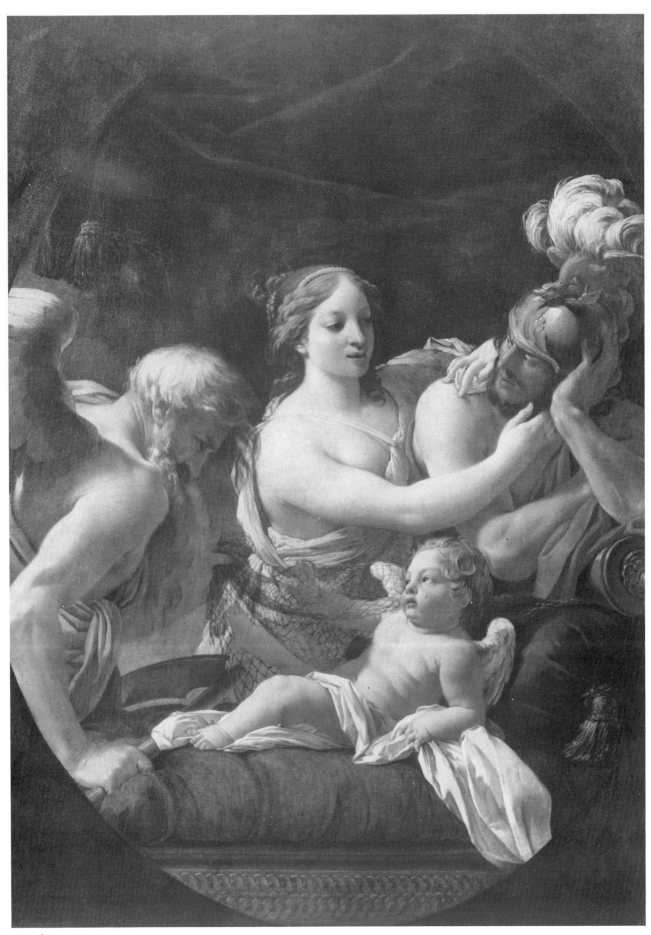

**28. Simon Vouet**
*Venus, Mars, Cupid and Chronos*

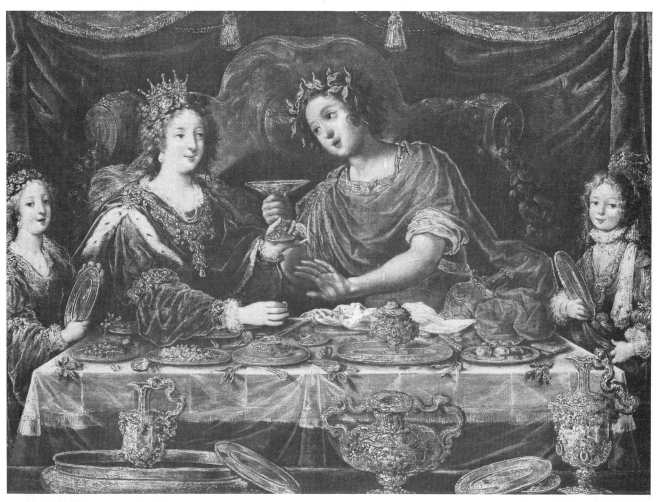

**29. Claude Vignon**
*Banquet of Anthony and Cleopatra*

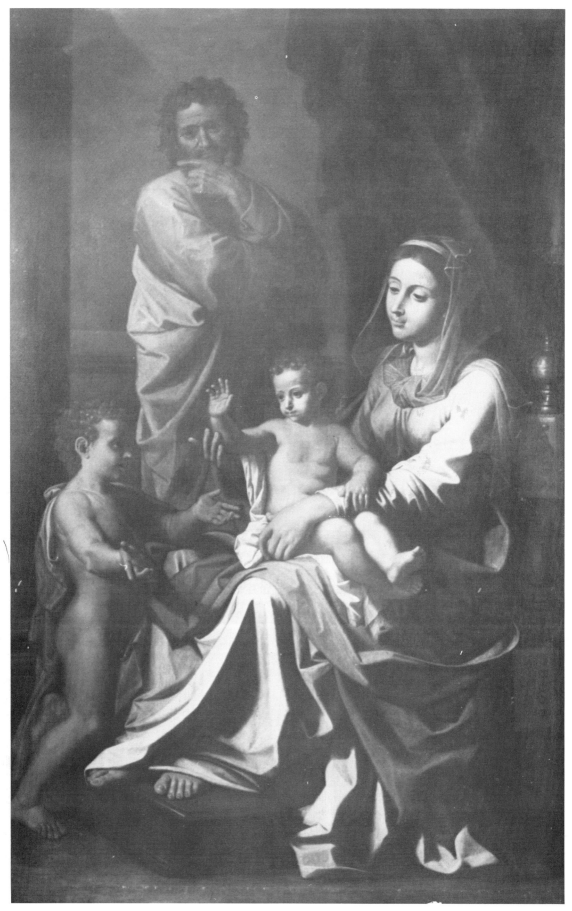

**30. Nicolas Poussin**
*The Holy Family*

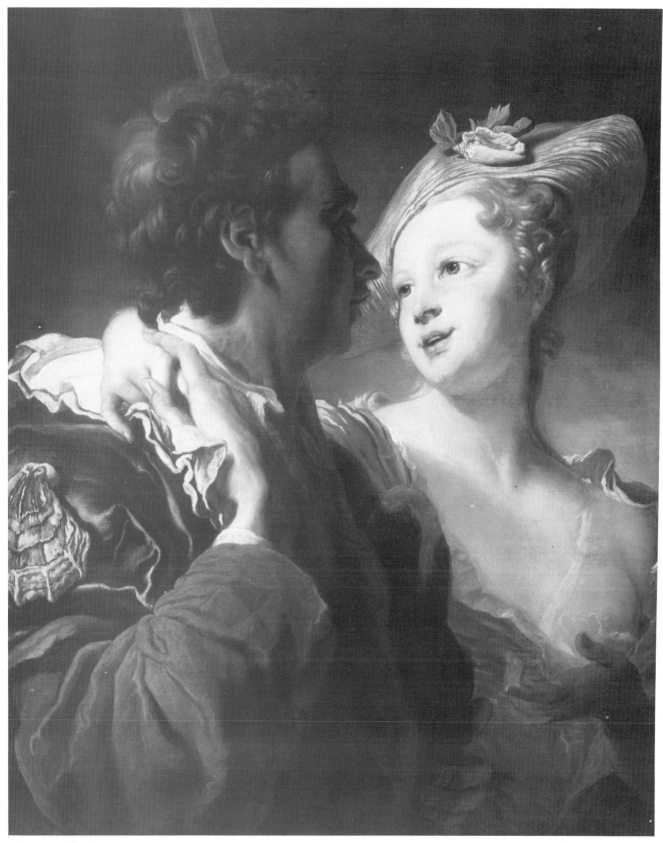

31. **Pierre Gaudreau**
*The Lover's Pilgrimage*

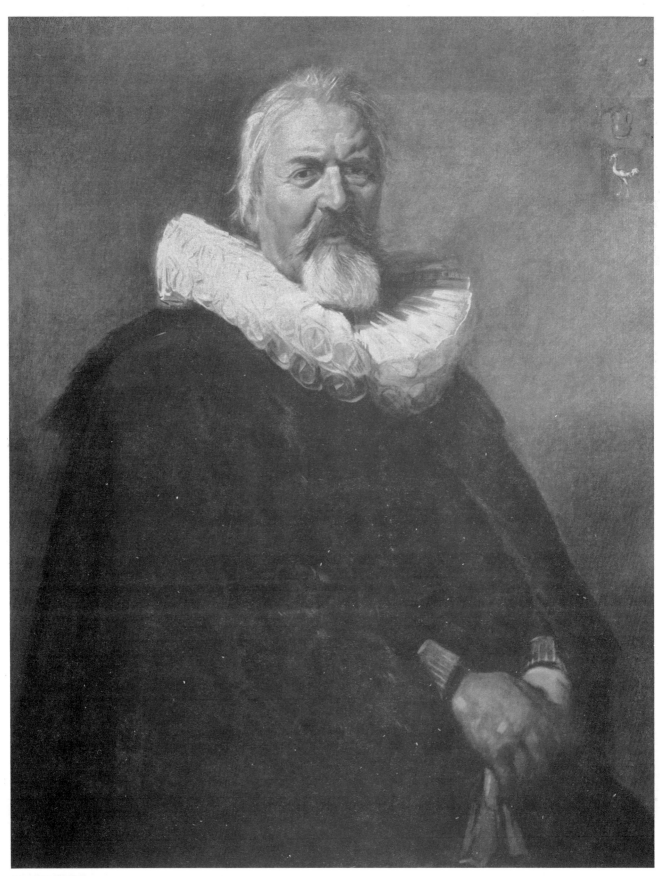

**32. Frans Hals**
*Portrait of Pieter Jacobsz. Olycan*

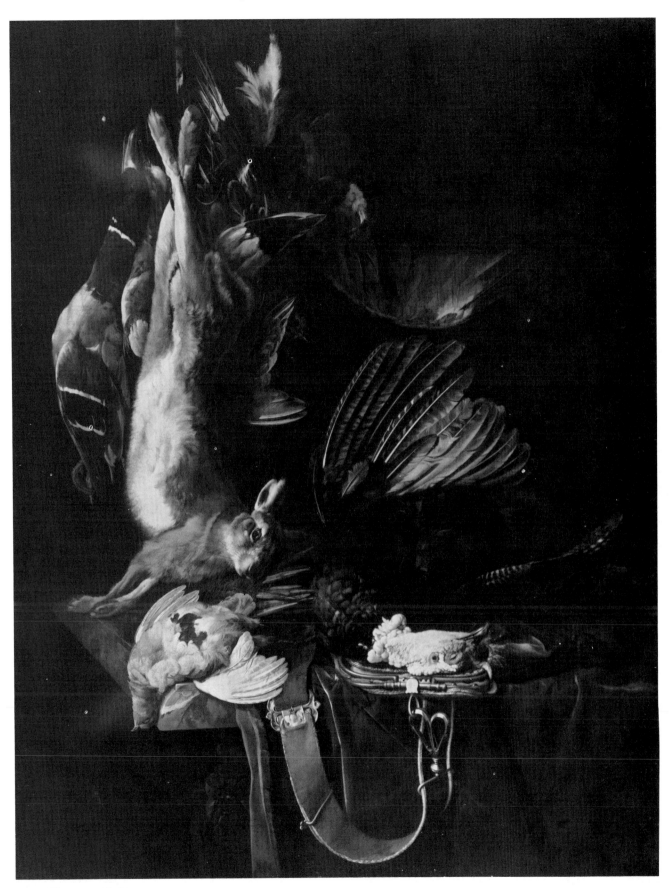

33. **Willem van Aelst**
*Still Life with Dead Game*

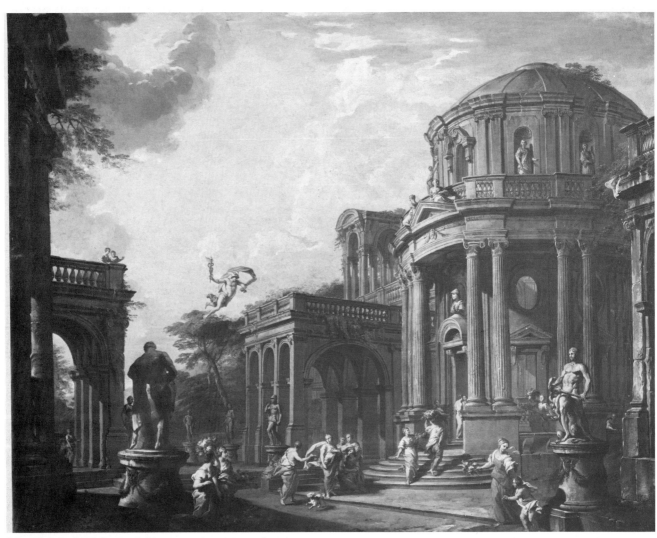

34. **Giovanni Paolo Panini**
*Hermes Appears to Calypso*

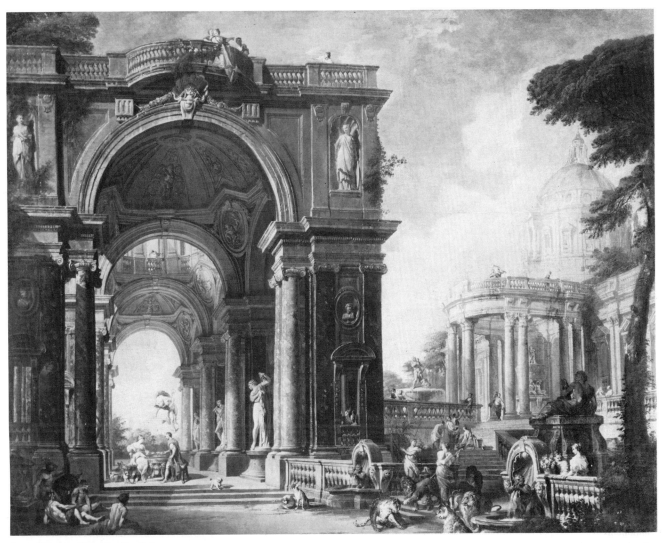

35. **Giovanni Paolo Panini**
*Circe Entertains Odysseus at a Banquet*

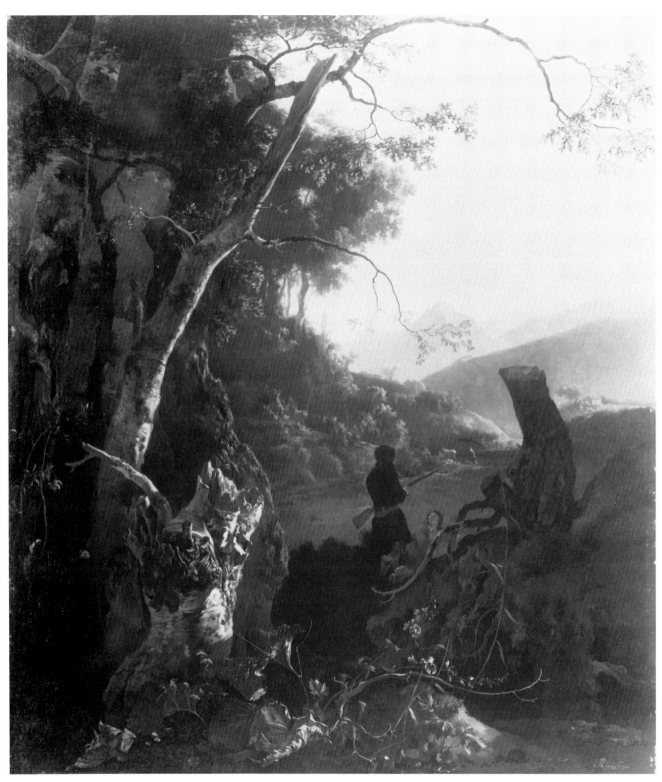

**36. Adam Pynacker**
*Landscape with Hunters*

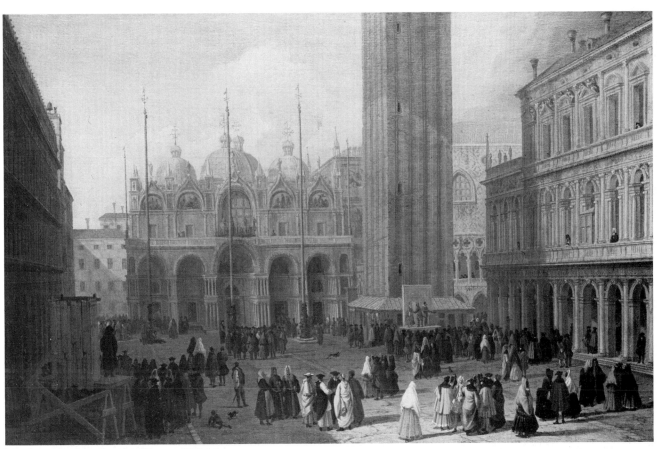

37. **Luca Carlevaris** and **Giovanni Richter**
*Piazza San Marco Towards San Marco*

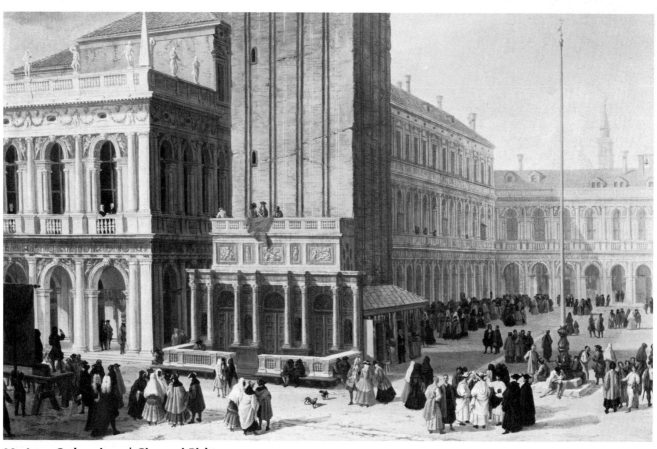

**38. Luca Carlevaris** and **Giovanni Richter**
*Piazza San Marco Towards the Piazetta*

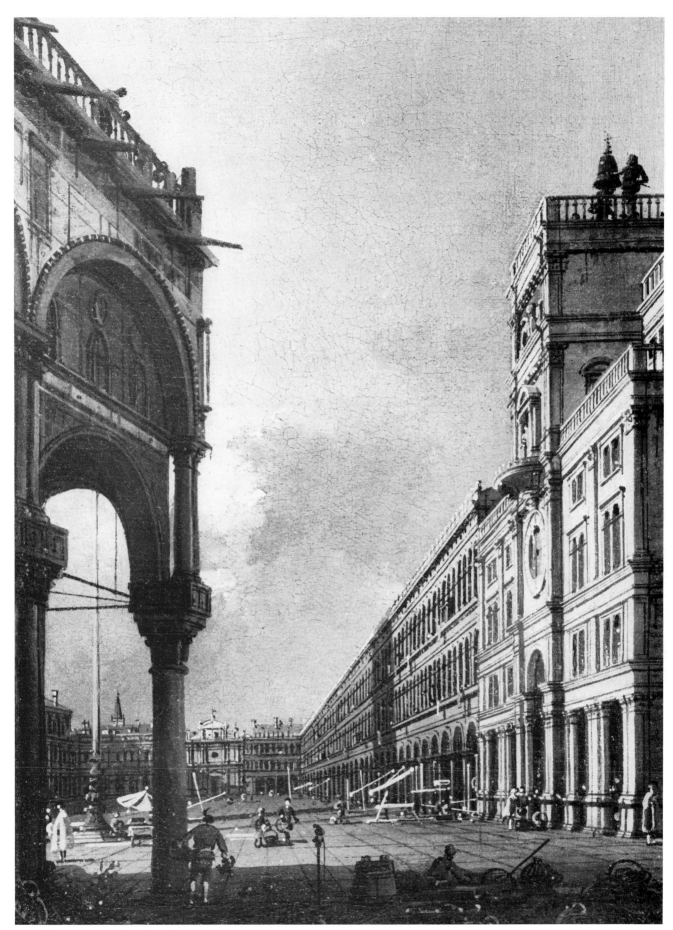

**39. Giovanni Antonio Canaletto**
*Piazza San Marco, From Campo San Basso*

71

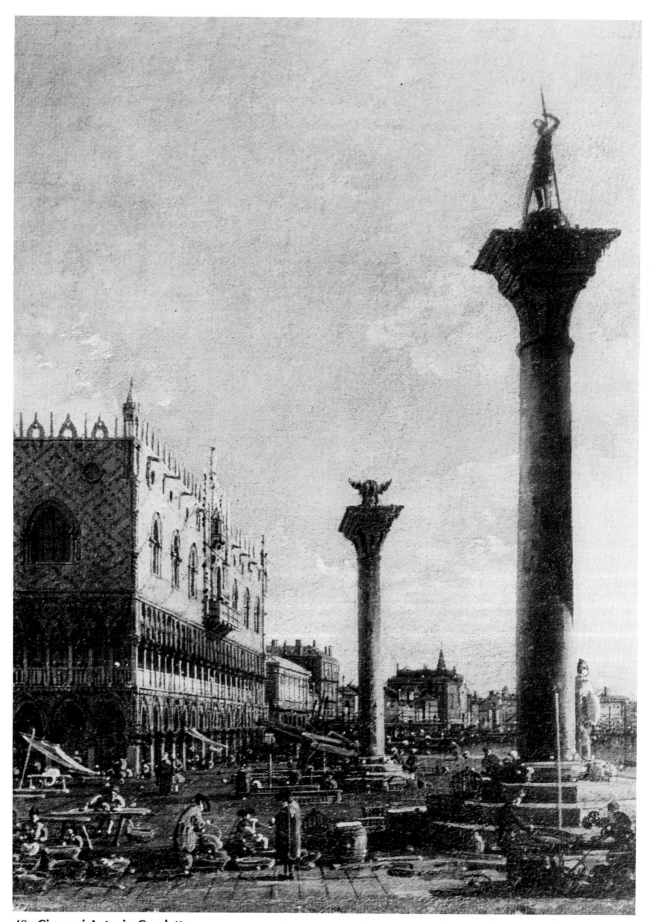

**40. Giovanni Antonio Canaletto**
*The Riva Degli Schiavoni Towards the East*

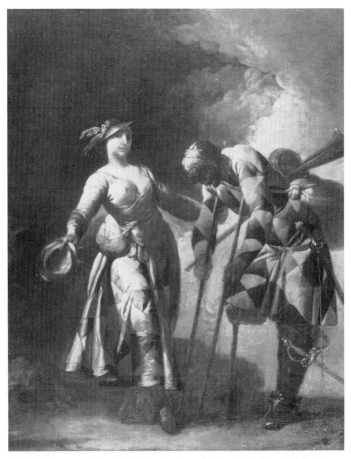

**41. Giovanni Domenico Ferretti**
*Harlequin as Crippled Soldier*

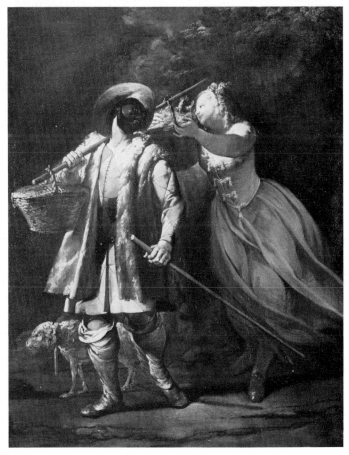

**42. Giovanni Domenico Ferretti**
*Harlequin as Peasant*

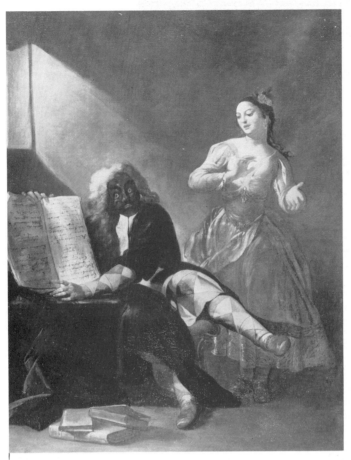

**43. Giovanni Domenico Ferretti**
*Harlequin as Scholar*

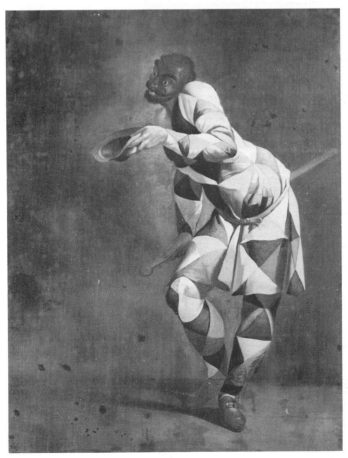

**44. Giovanni Domenico Ferretti**
*Harlequin as Beggar*

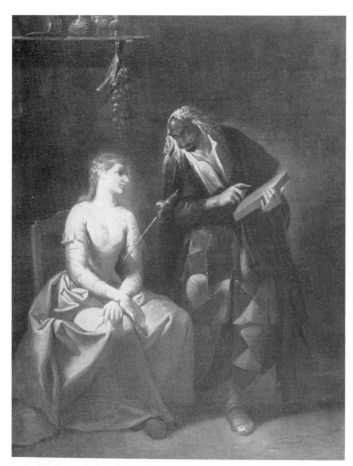

**45. Giovanni Domenico Ferretti**
*Harlequin as Doctor*

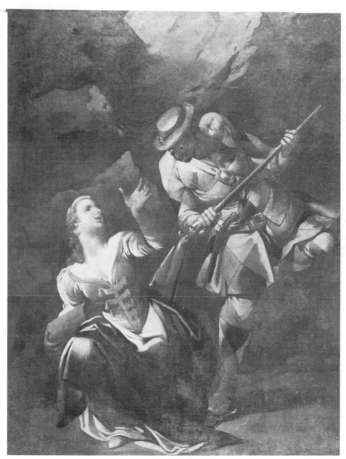

**46. Giovanni Domenico Ferretti**
*Harlequin as Brigand*

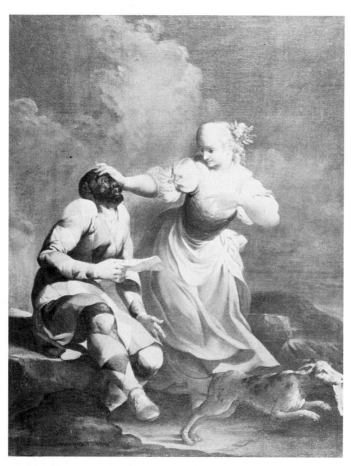

**47. Giovanni Domenico Ferretti**
*Harlequin as Rejected Lover*

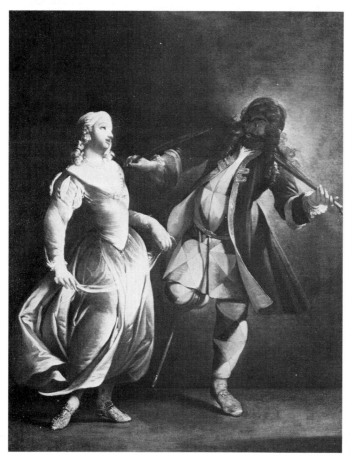

**48. Giovanni Domenico Ferretti**
*Harlequin as Dancing Master*

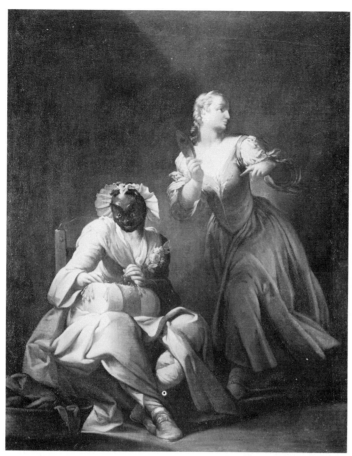

**49. Giovanni Domenico Ferretti**
*Harlequin as Lacemaker*

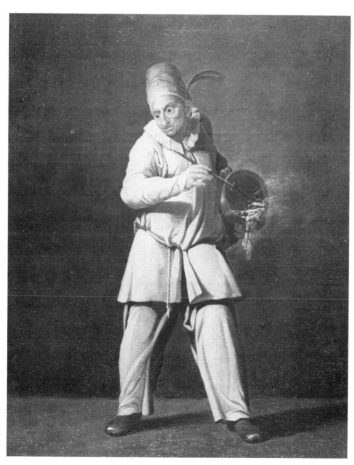

**50. Giovanni Domenico Ferretti**
*Pulcinella with a Cooking Pot*

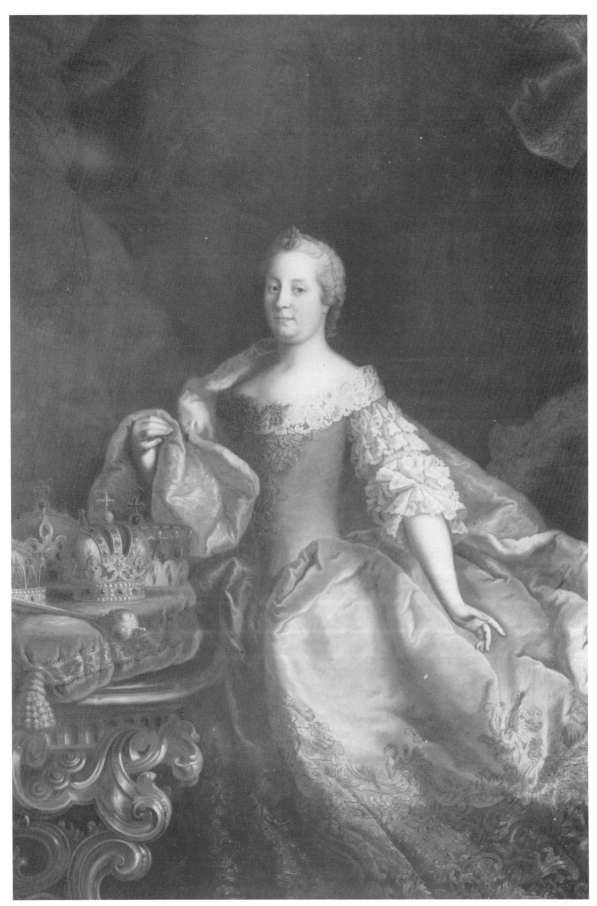

**51. Martin van Meytens**
*Portrait of the Empress Maria-Theresia of Austria*

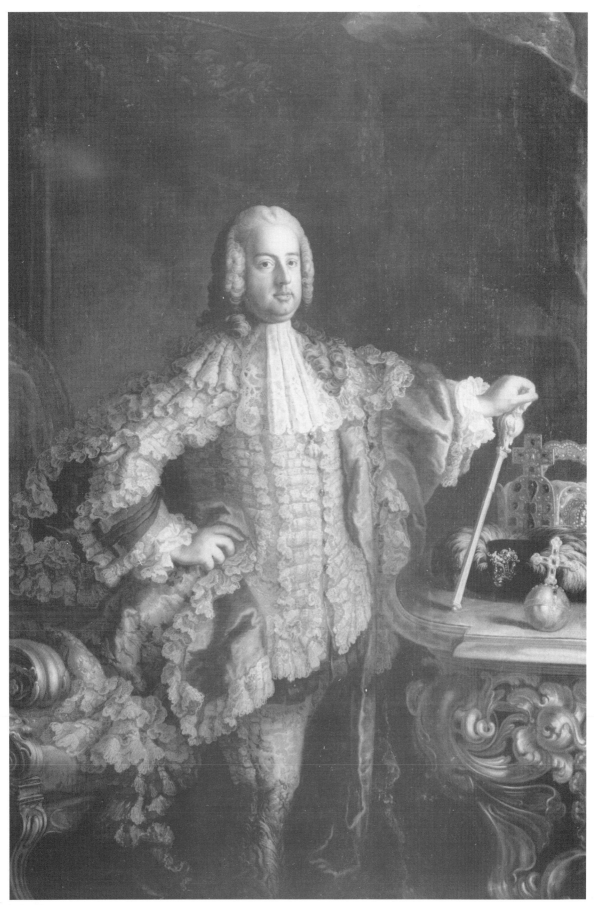

**52. Martin van Meytens**
*Portrait of the Emperor Francis I*